HIDDEN
HISTORY
of
AUBURN

HIDDEN
HISTORY
of
AUBURN

Kelly Kazek

THE
History
PRESS

Published by The History Press
Charleston, SC 29403
www.historypress.net

First published 2011
Second printing 2012

Manufactured in the United States

ISBN 978.1.60949.292.2

Library of Congress Cataloging-in-Publication Data

Kazek, Kelly.
Hidden history of Auburn / Kelly Kazek.
p. cm.
ISBN 978-1-60949-292-2
1. Auburn University--History. I. Title.
LD271.A6615K29 2011
378.761'47--dc23
2011017847

To the Auburn University family

All In.

Contents

Contents

Preface

Throughout the text of *Hidden History of Auburn*, the university is often simply referred to as "Auburn." The university began as the East Alabama Male College and then was the Agricultural and Mechanical College of Alabama from 1872 to 1899 and the Alabama Polytechnic Institute from 1899 to 1960. During that time, you will find that students and faculty—and even newspaper reporters—referred to the college as "Auburn."

In the first *Glomerata* yearbook produced in 1897, the cheers refer to the college:

> *Rackety-Yak-te-Yak-te-Yak*
> *Zip-rah! Zip-rah!*
> *Here we are, here we are!*
> *Auburn!*
>
> *Auburn, Auburn*
> *Is our cry*
> *V-I-C-T-O-R-Y*

The name was officially changed to Auburn University in 1960.

Some contents of this book may not seem to fit the title. Obviously, Aubie and Toomer's Corner are not really "hidden." However, I tried to tell the interesting backgrounds of Auburn's landmarks, people and traditions, about which many people may not know.

I hope you discover something new and interesting on these pages.

Acknowledgements

Writing this book required lots of research into family histories. Many people in the Auburn family helped with this task, and most are mentioned within the body of the book. As I do in my career in journalism, I attributed most sources within each chapter.

Others who helped but may not be listed within, and those who went above and beyond with assistance, are Jennifer Toomer Reed; Mike DeMent; David Housel; Missy Dye McDonald; Liz Peel; Jeremy Henderson; Dwayne Cox and John Varner with Auburn University Libraries; the Auburn Chamber of Commerce; Curtis Coghlan of the *Huntsville Times*; Mary McNamara of the *Los Angeles Times*; Grant Davis; Greg Parsons; Joe McAdory of the *Opelika-Auburn News*; Mike Clardy with Auburn University Media Relations; Mike Overstreet; Lee Andrews; Burt Cloud; the Auburn Alumni Association; Steve Means; Marianne Hudson and Roy Crowe with the Auburn University College of Veterinary Medicine; Benita Edwards; Melanie Flannagan Elliott; Mike Watson; and John Penick. Past editions of the *Auburn Plainsman* and the *Glomerata* were also very helpful.

A special thank you to Auburn student Rebecca Croomes, a very talented photographer and newspaper intern who took a break from studying to take photos for this book.

Thanks always to my daughter, Shannon, who will be a freshman at Auburn in the fall of 2011, God and my checkbook willing. And to my brother, Kevin Caldwell, one of the biggest Auburn fans ever created, for listening every time I called and said, "Hey, did you know…?"

Introduction

The day I graduated from Auburn University in 1987 is among my most vivid and sweat-inducing memories. On what should have been a triumphant day, I found myself in the midst of a nightmare. It was no walking-naked-into-class or sleeping-through-the-exam nightmare.

This one was all too real.

When my name was called, I proudly walked across the stage of Beard-Eaves Memorial Coliseum to accept my diploma—or diploma cover. With so many students graduating, and with no idea how many would attend the ceremony, university officials would present the empty covers and then ask students to go to tables to pick up the real deal.

With my parents, grandparents, brother and a few friends in tow, I approached the "C" table and said my name: Kelly Caldwell.

A woman behind the table searched through alphabetized file folders, stopping at mine to read some notes. "Looks like your diploma's not here. You were short some course hours."

Do what? Say who?

This couldn't be happening.

I had been so paranoid that some of my transfer hours from summer courses would not be calculated that I had called the registrar's office no fewer than six times during the academic year. I had repeatedly been assured that all was well.

I told the woman her information wasn't correct and asked what I should do.

She shrugged and said, "You'll have to go to the registrar's office. It will open on Monday."

By Monday, I planned to be living in Atlanta. I had no car, no job and no place to live, but I planned it, just the same. I already had packed the contents of my apartment on Genelda Avenue in Auburn, the place where I had used a crate as a bedside table and eaten more macaroni and cheese than I cared to think about. The place I would never forget because it was the site of my most wonderful college memories. Now there was no going back.

"I need to go to the registrar's office *now*," I said.

"It's not open on Saturdays."

Thank goodness for my mother, whose protective instincts kicked in: "Wanna bet?"

She and Dad had struggled for four years to get me to this point. No one was going to ruin my big day. It must have been ninety-seven degrees, but

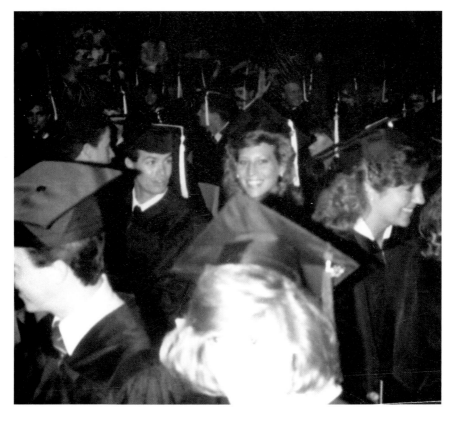

The author, smiling at center, on the day she graduated from Auburn University in 1987. *Author's collection.*

Mom and I walked across campus in our high heels to the office. It was locked, but Mom pounded on the door and demanded entry. Thankfully, two women were inside and, taking one look at the determined expression on my mother's face, agreed to check my files.

I have never since felt the relief I experienced that day when the woman said the appropriate transcript was in my file and withholding my diploma had been a clerical error. She promptly handed me the document, one of the most important pieces of paper I received in my life.

Other documents would play a role in my Auburn years—the $1.83 check to Taco Bell that bounced so that I ended up with a $40.00 burrito, my War Eagle Supper Club Membership Card, my student football tickets, my paychecks from my part-time job at Godfather's Pizza.

The years preceding that terrifying graduation day were some of the best of my life. I chose to attend Auburn for the worst of reasons—I followed a boyfriend—and though that relationship didn't last, my relationship with Auburn is forever.

When I decided to write this book, editors at my publishing house, The History Press, were immediately onboard, realizing that Auburn's popularity following the national championship season would help market the book. Editors couldn't know that Auburn is always loved among its fans and alumni, no matter how the football team is faring.

Auburn is, more than anything, an emotion.

It's the goose bumps you feel when the Auburn University Marching Band plays the first strains of the fight song.

It's the gathering of tears when War Eagle VII takes flight.

It's the swelling in your chest when the LED screen at Jordan-Hare Stadium displays the words, "We Must Protect This House."

Most of all, it's the pride you feel when you tell someone, "I am an Auburn graduate."

Auburn is family. It doesn't matter if someone graduated in 1960 or 2001, or if he didn't graduate at all; people who love Auburn are related.

What I found so gratifying in conducting research for this book was my reception by those I interviewed. Rather than having to present credentials of my journalism background, honors and book history, I had only to say, "Hi, I'm Kelly Kazek, Auburn class of 1987." I was immediately trusted, immediately a member of the family. I had the privilege to meet some prominent members of the Auburn family.

Several of them, now in their seventies and eighties, and even one in her nineties, allowed me to record memories that may otherwise have been lost to history. I am truly grateful.

On the flip side, this task brings great responsibility.

I must do Margaret Toomer Hall, daughter of Toomer's Drugs founder Shel Toomer, the honor of accurately recording her family's history.

I must ensure that Thom Gossom's story of being one of Auburn's first black athletes respectfully depicts his experience.

I must guarantee that the memories recounted by Margaret Linch Melson of her grandfather, the first law officer killed in Lee County, illustrate a loving family man and loyal law officer.

And, when all is done, I must do right by Auburn.

AUBURN AND ALABAMA: THE STORIED RIVALRY

It's been a good couple of years for the state of Alabama. The Alabama Crimson Tide won the BCS National Championship in 2009, and the Auburn Tigers won in 2010.

The total number of championships won by these two respected institutions is much disputed. When Alabama won in 2009, it claimed thirteen titles. Auburn has claimed two. Both claims are inaccurate.

As you will learn in the chapter on Kirk Newell, one of Auburn's greatest all-around athletes, Auburn won a national championship as Alabama Polytechnic Institute in 1913. Auburn was the first university in the South to accomplish this feat—the first outside the Ivy League and a handful of northern universities. Auburn officials choose not to claim the title because it was earned under a differing system, as were many claimed by the University of Alabama.

According to the Billingsley Report (billingsleyreport.com), Auburn has won four championships (1913, 1957 [officially claimed], 1983 and 2010 [officially claimed]) and Alabama has won six (1925, 1926, 1961, 1979, 1992 and 2009).

The Associated Press did not begin naming champions until 1936. Auburn has been named champion by other organizations in 1910, 1913, 1914, 1958, 1983, 1993 and 2004. Since 1892, Auburn has completed seven perfect seasons in which the Tigers were undefeated and untied: 1900, 1904, 1913, 1957, 1993, 2004 and 2010. Auburn has won a total of eleven conference championships, including seven SEC Championships.

In its list of Top Programs of All Time, Billingsley ranks Alabama third, with a record of 831-310-44, and Auburn fourteenth, with a record of 700-402-48 at the end of the 2010 season.

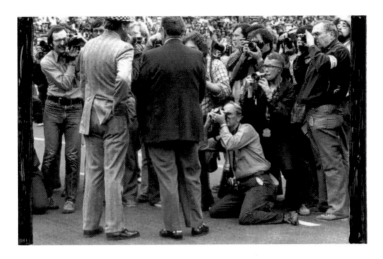

Ralph "Shug" Jordan and Paul "Bear" Bryant face the press before the 1975 Iron Bowl in Birmingham. Shug Jordan retired that year. *Photo courtesy of the* Anniston Star, *from the collection of James Lloyd.*

Although this is not a book about football, you will find several references in its pages to this intense football rivalry, including the recent poisoning of the historic Toomer's oaks and the time Bear Bryant said if 'Bama lost the Iron Bowl, he'd go home "to plow," and the mascot, Aubie, pushed a plow onto the field before the game.

This book was carefully researched, and I gathered as much of the information as possible from the people who witnessed or remember events. I also relied on newspaper accounts, historical documents and tales from the university's yearbook, the *Glomerata*.

Its sections, all interspersed with family histories, include: "Lost and Loved Landmarks," which has stories of the Doll House and Sani-Freeze, the Kopper Kettle explosion, Old Main and Samford Hall, Momma Goldberg's, War Eagle Supper Club, the Foy Information Desk and J&M Bookstore. "Murder, Mayhem and Mystery" includes stories of an 1871 roommate murder, the killing of Sheriff Buck Jones, the story of football great Bobby Hoppe and a shooting one hot summer night, the unsolved murder of Jethro Walker, the ghost of the University Chapel and the slave who erected a monument to his slain white friend. "Notable and Notorious" is a section of those who attended or taught at Auburn, including famed archer Howard Hill, the only man to perform the arrow-within-arrow shot; Kirk Newell, who captained the 1913 championship team; Toni Tennille,

the "chick singer"; Bobby Goldsboro; Thom Gossom Jr., the first black athlete to graduate from Auburn; Allie Glenn, who is credited with choosing Auburn's school colors; Alvin Vogtle and Winston Garth, Auburn friends who reunited in a POW camp; little Charlie Miles, the "lizard boy"; and the man who was buried in his feather bed. "Tiger Traditions" tells the back stories of several well-known traditions, such as the origins of "Bodda Getta," the story of Toomer's Drugs and Toomer's Corner, the history of the fight song and debut of the eagle's pregame flight, the beginnings of Aubie the mascot and a chapter on college pranks and hazing: panty raids, streaking and the time the women's dorm windows were installed backward allowing the boys to see into the showers. And finally, "Auburn Achievers" is a partial listing of alumnae who have gone on to great accomplishments and their recollections of Auburn.

Twenty-four years after my graduation, Beard-Eaves Coliseum has been abandoned for the more intimate Auburn Arena. Many other things have changed. Most of the clubs and restaurants I frequented are gone. Students no longer walk freely from frat party to frat party, listening to cover bands and drinking keg beer, which, if you were female, was always free. A new student center was built, and streets were closed to create a "walking campus." But Auburn, the emotion, will never change.

Writing this book has been one of the most enjoyable experiences of my career. I hope you enjoy the stories contained in this book and that you will be proud of the job I have done.

Like you, I believe in Auburn…and love it.

Lost and Loved Landmarks

Kopper Kettle: It Was a Blast

Oh, The Kettle's gone.
Long live its memory.
—"The Kettle's Gone"

Early on a Sunday morning, with college students still abed, the village of Auburn is as quiet and quaint as when it was founded. The streets, so jammed on game days with slow-moving cars and pedestrians shouting "War Eagle!" are empty, with the exception of those few people who need to be at church early to ready it for parishioners.

It was such a day in 1978 when the streets of Auburn became "like a war zone" and tragedy was narrowly averted.

At about 8:00 a.m. on January 15, in subfreezing temperatures, downtown Auburn exploded. While dozens of businesses along Magnolia Street and beyond were damaged, the blast seemed to center on a popular eatery. It has ever since been known as the Kopper Kettle Explosion.

Because of the hour and day, no one was killed or injured. Still, it would take the city years to recover.

Lieutenant Tamp McDonald of the Auburn Fire Department was the first official on the scene. He had been coming to check the source of the strong smell of gas when the blast occurred. Had he rounded the corner a few seconds later, his fate may have been different.

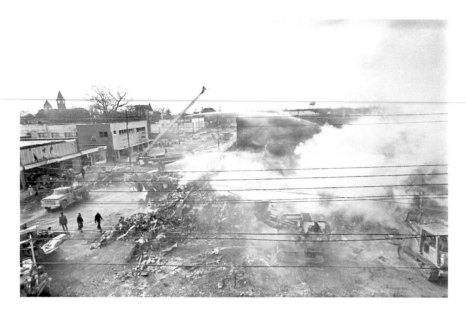

Early on a Sunday morning in 1978, a gas leak caused an explosion in downtown Auburn. *Courtesy of Jeremy Henderson/thewareaglereader.com.*

"I ran as fast I could for the truck to call the men on the radio and tell them the town had just blown up," McDonald told the *Opelika-Auburn News* that day.

Other residents would later report close calls. Local attorney Andy Gentry had planned to go to his office upstairs in the Brownfield building, but his wife asked him to stay home. The building, which the Gentrys owned, was demolished.

At 8:30 a.m., early service would have begun across from the blast at Auburn United Methodist Church, and dozens of parishioners would have been injured. A pipeline safety worker determined that the explosion was caused by a gas leak in the building housing the Kopper Kettle, and because it took time to get the gas main shut off, crews had difficulty extinguishing the resulting fires.

Sixty-seven businesses were damaged.

When the smoke and fire cleared, the city was covered in icicles from the firefighters' water and debris from the blast. Grant Davis, a graduate student asleep in the old Beta Theta Pi house two blocks away on College Street, recalls being awakened by the blast. "It literally shook me out of bed," he says. He and his fraternity brothers ran outside to see debris from downtown falling around them.

David Housel, former editor of the *Auburn Plainsman* and university publicist who later became a beloved athletic director, was still in bed in his home about four blocks away when he felt the concussion from the explosion. At the time, he also worked as a freelance reporter, and he rushed to the scene to write a story for the *Birmingham News*.

Housel, emergency workers and curious residents were greeted with a shocking sight.

In a 1998 retrospective of the blast by the Associated Press, Auburn resident Alan Davis said, "We were having to walk up the center of the street because you couldn't see your feet. The cloud of smoke was that dense...All the mannequins had blown out into Gay Street. They looked like they were body parts. We thought they were pieces of people blown all out into the street."

To the students, the loss of the fondly named "Kopper Kommode" was immeasurable. Upon opening in the 1960s, the Kettle became known for its ten-cent Kettleburgers and coconut pies. The Kopper Kettle was a favorite because it served breakfast all day and stayed open late—late enough to be the go-to spot for after-party gatherings. For a while, according to Jeremy Henderson of thewareaglereader.com, late-night ketchup fights became such a problem that the owners began to fine the perpetrators.

Henderson also recalled some freak occurrences of the blast. Chairs from a dental office were blown three stories into the air, and dental records were found six miles away. The marquee of the Village Theater, which had been showing *Close Encounters of the Third Kind* before it was gutted by the blast, was left only with the line "We Are Not Alone."

Local attorney Jimmy Sprayberry, whose office was on the second floor of the Kopper Kettle building, said certificates on his office wall were blown away by the blast.

"My law school diploma came floating down across from the university library, and someone found it and brought back," he recalls. "One of my honorary certificates came down on the Johnston's farm three or four miles away. One of my Bench and Bar Honor Society certificates came floating down in my mother's front yard. She lived at 371 Gardner Drive." Chairs from Sprayberry's office were found on the roof of Auburn National Bank.

Soon after the blast, entrepreneur Chuck McDowell and his Kappa Alpha fraternity brother Chuck Staub went into action. The Chucks and their fraternity brothers went to a T-shirt designer and asked him to create shirts with the slogan "I survived the Kopper Kettle Explosion," featuring a graphic depicting a mushroom cloud billowing from a kettle. The shirts were sold at the frat house and around campus.

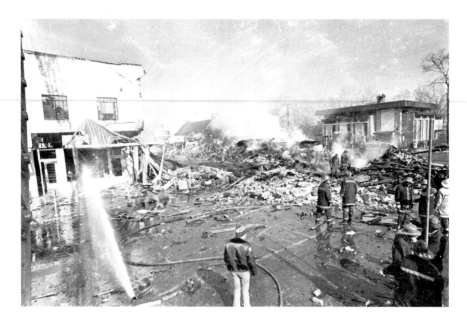

It would take months for the city to recover from what became known as the Kopper Kettle Explosion. Students sold T-shirts and wrote a parody song about the event. *Courtesy of Jeremy Henderson/thewareaglereader.com.*

McDowell also wrote a commemorative song called "The Kettle's Gone," a parody of Ronnie McDowell's "The King is Gone," which had been released not long before the explosion following Elvis Presley's death. McDowell does an impressive Elvis impression on the recording, which features the following lyrics:

> *There was a place where you could eat*
> *Any time that you could want.*
> *A happy place filled with love,*
> *With kindness, and such warmth.*

"Of course, we wouldn't have done parodies of it if anyone had been hurt," Chuck McDowell says now. "As horrific as the explosion was, it was equally astounding that no one was injured or killed."

The song described—tongue in cheek—the demise of the beloved landmark: "It was over there, it was over there, way over there, about four blocks." It ends: "Goodbye, Kopper Kettle. It was a blast."

A friend at the campus radio station WEGL helped McDowell record the song, and his father loaned McDowell money to make forty-five rpm

records. The records were sold at J&M bookstore and other stores around town, but McDowell said the project never made back its investment. "We were just trying to break even on it," McDowell said. "It was just a lark."

Today, some forty-fives of "The Kettle's Gone" survive. The song can also be heard on YouTube, where Jeremy Henderson created a slideshow of photos from the explosion to go with the music.

MEMORIES OF ICE CREAM AT THE FLUSH

In the mid-1930s, the Meaghers were one of the most recognizable couples in Auburn. They lived in a cozy home on East Glenn, near Gay Street.

Clyde R. "Red" Meagher (pronounced *Mee-ger*) Sr., born in 1902, was a carpenter who owned several buildings that he would rent as student apartments or businesses. Luckie Thomas Meagher, born in 1905, opened a kindergarten about 1940 in the small building behind the couple's home. There, she would teach generations of children in the decades before kindergarten became part of the public school system.

Everyone knew and loved Mrs. Meagher. One lasting impact she had on the city was when she went in search of a doctor in 1947 to help with one of her students who stuttered. She met speech pathologist Dr. A. Harrington, and he agreed to test Lee County children for speech impairments. Before long, the Auburn University Speech and Hearing Clinic was organized.

Luckie's grandson, Mark Meagher, said his grandmother kept in touch with her students through their high school careers. "In the early 1960s, she started the tradition of giving a graduation party to each of her classes when they graduated high school. She would post pictures of all of her classes in the kindergarten, and the party was always surprisingly well attended. Auburn was a pretty close-knit town at that time. This tradition continued well after she retired in 1978, until her last kindergarten class graduated in 1990."

The kindergarten building, as well as the Meaghers' home and that of Luckie's parents, still stands off East Glenn and is now student apartments.

The Doll House

In 1937 or 1938, Red began work on another of his pet projects. He built a small house on East Glenn on a lot next to the Sinclair Station. The tiny restaurant had a front porch with two dormer windows above it. The restaurant was built of scrap lumber with a tin roof, recalled his son, Clyde Meagher Jr.

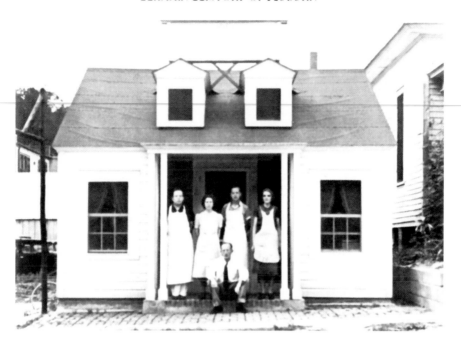

Clyde "Red" Meagher (seated) poses with his wife, Luckie (standing near Red), and employees at the grand opening of the Doll House, a sandwich shop on East Glenn that would become an Auburn landmark. *Courtesy of Mark Meagher.*

It looked like a child's playhouse, so Red placed a few dolls inside and named it the Doll House.

Students flocked to the eatery, finding good but inexpensive barbecue sandwiches, hot dogs and burgers. It was one of two restaurants in downtown Auburn at the time, as most students ate at their boardinghouses or the university cafeteria.

Mark Meagher said that his grandmother's cooking was a draw for students: "My grandmother's signature hot apple turnovers were made each night by her and her sister."

The Meaghers ran the shop until about 1941, when Luckie put her foot down. With just Red, a cook named Childers and one waitress, she'd been working eighteen-hour days for years, and she told Red, "It's me or the Doll House."

Red chose Luckie, of course, and they rented the building to Archie and Edna Cook McKee, who kept the business as an eat-in sandwich shop.

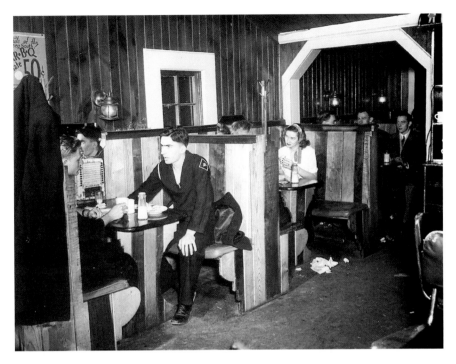

Students at Alabama Polytechnic Institute having lunch at the Doll House in February 1946. *Courtesy of Auburn University Libraries.*

Sani-Freeze

About 1952, the building was rented to Bennie Hunt, who requested modifications. It was made into a walk-up ice cream and sandwich stand, where customers approached one of two small, screened windows and placed an order for a foot-long hot dog with special-recipe chili or a chocolate-dipped cone.

It was named Sani-Freeze. By then, the building was a little more dilapidated and had a homey feeling to it. In short, it had "atmosphere."

Soon, lines of students meandered across the lot, each student waiting his or her turn to order an upside-down banana split.

About this time, a company was marketing its new product, Sani-Flush, a toilet bowl cleaner. Based on its shabby appearance and not its food, the beloved Sani-Freeze landmark became known for a time as the Sani-Flush, and later simply "the Flush." (Many of these students soon dubbed the Kopper Kettle, another eatery in town, the Kopper Kommode.)

The Flush was one of the first places roommates took new students and where men took their dates. It was always at the Flush where a late-night

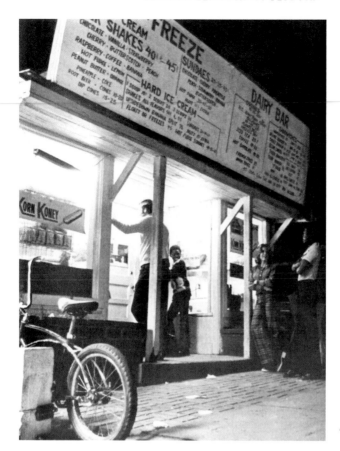

The 1975 edition of the *Glomerata* featured this photo of students ordering at the walk-up window at Sani-Freeze. *Used with permission of Auburn University Libraries.*

snack was in order to complete cramming sessions. In 1979, student Donna Cook wrote in the *Glomerata*, "The small white building on West Glenn Avenue is not very noticeable to passersby on the street, but in the minds of most Auburn students, the Sani-Freeze (affectionately known as "The Flush") is as much a part of Auburn tradition as Samford Tower and the Orange and Blue."

In the 1985 *Glomerata*, writer Ben Athens noted, "As long as 'The Flush' is there, I will never mind standing in the cold and helping this tradition live on. On a binge, a study break, or a date, I'll meet you at 'The Flush.'"

In the 1990s, the lot holding Sani-Freeze and the three adjoining lots were leased by AmSouth Bank from Clyde Meagher Jr. Mark Meagher said, "My father, sensitive to the legacy of 'The Flush' to Auburn, did check into moving the building to a nearby lot. But the foundation was too rotten, and building a new building could not be justified with the $250-per-month

rent." Clyde Jr. was reluctant to sell but couldn't turn down an offer of three times the money.

When AmSouth announced plans to tear down the old building and construct a bank, students went into action. The campus was covered with "Save the Flush" signs, and stories appeared in newspapers across the state. In an article in the July 4, 1993 edition of the *Tuscaloosa News*, student government president Pat Brown said, "It's a big uproar down here. I don't think they realize what that dilapidated old building means to Auburn. It's tradition."

Bennie Hunt's son, Butch, moved the business to a location at Glenn Avenue and Dean Road, but it wasn't the same. The Flush belonged in the little Doll House building with its peeling paint and remnants of sweet and spicy smells, not in a strip mall. It closed in 2000.

Red Meagher died in 1980, and Luckie followed in 1995. They are buried in Auburn's historic Pine Hill Cemetery, where actors portray them each year during the cemetery's Lantern Tour.

THE LOVELIEST BUILDING ON THE PLAINS

Charles Bowles Glenn was seventeen years old when he had the honor of laying the first brick in Auburn's most iconic building, Samford Hall. Glenn, born on December 1, 1871, was the son of one of the town's most prominent citizens, Emory Thomas Glenn, treasurer of the college in Auburn, which at the time was known as the Agricultural and Mechanical College of Alabama. Charles also was the grandson of the Reverend John Bowles Glenn, the first president of the college's board of trustees.

Charles was a young man from good stock with a promising future, and that was likely why he had the honor of literally laying the university's foundation. When construction on Samford Hall was begun, the college was in need of a building following the demise of Old Main.

Old Main, the first facility on what was then the campus of East Alabama Male College, had been built in 1859 for classrooms and a library. The four-story building was Italianate in design.

During the Civil War, when students and faculty enlisted and the college was empty, the stately twin-turreted Old Main was used as a hospital for Confederate soldiers.

Bodies were strewn on the lawn that cadets once crossed to reach classrooms. Elsewhere on the grounds, soldiers from nearby Camp Beauregard or Camp Johnson conducted training exercises.

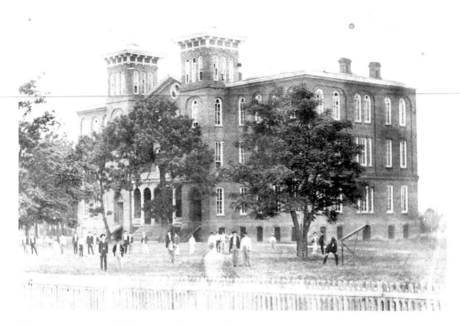

This picture of the Old Main building was taken in 1883. Located on South College Street, it was the original building of the East Alabama Male College. It was originally used for classrooms and the library and served as a hospital during the Civil War. The building burned in 1887 and was replaced with Samford Hall. *Courtesy of Auburn University Libraries.*

On June 24, 1887, a fire gutted Old Main, leaving the college without classroom space. Students temporarily met in the oldest structure in town, the 1851 building that is now the University Chapel.

The 1898 *Glomerata* described Old Main:

> *For thirty years the old walls of the East Alabama Male College resounded to the tread of multitudes of college boys with but brief intermission in the sixties when it lent its full share of youthful chivalry to champion the Lost Cause, many of whom, leaving the loved halls of their alma mater to take up arms for God and country, returned no more, and now lie calmly sleeping 'neath the soil of many a hard-fought field. In 1887 the old East Alabama College, along with the library, museum, and several laboratories, was consumed by fire. By means of the insurance, assisted by a generous appropriation from the Legislature, the work of reconstruction was carried on rapidly, and the magnificent edifice, forming the keystone in our galaxy of buildings, now stands as a monument to the untiring labor and energy which raised it.*

Old Main's replacement, which would be known simply as the Main Building until 1929, was completed in 1888. Bricks were salvaged from the ruins of Old Main, and the main foundation block on the front corner of the building is inscribed, "1888 Agricultural and Mechanical College—Alabama Polytechnic Institute—burned June 24, 1887—Bruce and Morgan, architects—James Smith, builder."

The design was similar in style to that of Old Main, but the new building had towers of differing heights rather than matching ones. Then, in 1889, a clock and bell were added to the taller tower. The bell tolled class times. The 1898 *Glomerata* described the building as having a chapel and library inside, along with classrooms, and an armory on the lower level.

In May 1929, the building was officially named in honor of William J. Samford, a Greenville, Alabama native who was elected Alabama's governor in 1900 and died in office on June 11, 1901. Samford, who had attended

Samford Hall, Auburn's showpiece, stands majestically on campus across from downtown Auburn. *Photo by Rebecca Croomes.*

Auburn, was a first lieutenant in the Confederate army during the Civil War and then opened a law practice in Opelika. He would later serve in the state legislature. He is buried in Rosemere Cemetery in Opelika.

The familiar clock tower atop Samford Hall was converted to operate on electricity in 1941. A carillon was added in 1977 to play Auburn's fight song and alma mater. According to the summer 2010 edition of *Auburn Magazine*, students used to climb to the clock tower and etch their names in the wooden walls and support beams. This attic space had formerly been used as a gym and theater. Students also reportedly once managed to get a cow to walk up the steep steps into the tower.

In 1995, when the tower's original Seth Thomas Clock Company clockworks were restored, Auburn's University Relations Department published a story by Roy Summerford: "Auburn University's 'Big Sam' got his hands back—all eight of them. Workers reattached the hands to Auburn University's 106-year-old clock shortly before noon on April 26, concluding a months-long refurbishing to restore the historic clock to its 1890s glory."

Currently, Samford Hall houses Auburn's administrative offices.

Charles Glenn, the young man who helped create the iconic building, would go on to a stellar career in education. He graduated from the Agricultural and Mechanical College of Alabama, as Auburn was known at the time, with bachelor's and master's degrees. He later earned a degree from Harvard. He married Elizabeth Roberts Douglass and would serve as superintendent of Birmingham, Alabama schools from 1921 to 1942.

Glenn was president of the National Education Association from 1937 through 1938, an honor published in the March 8, 1937 edition of *Time* magazine. The story read that association members "unanimously nominated and elected lanky Harvardman Charles B. Glenn, Superintendent of Schools in Birmingham, Ala., as president for 1937–38. Mr. Glenn's platform: 'I'm not one of those who feels he has got to save the world. Our main purpose is to elevate the profession.'"

Glenn died on April 21, 1967.

FOY: PRECURSOR TO GOOGLE

"Is this the answer-any-question desk?" I asked when a young woman answered the phone.

"Yes, it is."

"Can you tell me when the Foy Information Desk got its start?"

Dean Foy, who originated Auburn's information desk, remained popular with students until his death in October 2010 at age ninety-three. Here, he is shown with Aubie at a pep rally. *Courtesy of Susan Foy Spratling.*

The best way to get information on one of the country's most famous information desks is to call the desk. The student answering the phone said that the Foy Information Desk was started in the early 1950s by Dr. James Edgar Foy, Auburn's dean of students.

Dean Foy's initial idea was to provide a service that would help students who needed information on class schedules or university services. At the time, when no one had access to computers or the Internet, students found the hotline useful.

It was eventually extended into a twenty-four-hour service available to anyone who called 1-334-844-4244. Students who answer the phones are required to attempt to find the answer and spend three or four minutes per call. When the service was showcased on the *Today Show* in 2007 for a feature called "Five Things You've Never Heard Of That Could Change Your Life," Adam Glassman, creative director for *O Magazine*, said of the service, "Basically, it was the original Google."

The information line was featured in Oprah Winfrey's magazine, which led to the spot on the *Today Show*. During the segment, host Matt Lauer called Foy. He asked a student named Hannah the full name of the Barbie doll. Hannah put Matt on hold for a moment but returned with the answer: Barbara Millicent Roberts.

Students who staff the desk use the Internet and research books to answer questions, including "How many bricks are in Haley Center?" The students also have a database for trivia and commonly asked questions, like "How many Oreos does it take to stack to the moon?" or "How many marshmallows would it take to fill Jordan-Hare Stadium?"

Every freshman has to try it.

Currently, the Foy Information Desk is manned from 6:00 a.m. to midnight. Housed for many years in Foy Student Union, it was moved to the new student center upon that building's completion but retained the name of Dean Foy. The former student center was renamed James E. Foy Hall.

Although a few other universities offer fact lines, the Foy Information Desk service is one of the busiest and most recognized.

Dean Foy's daughter, Susan Foy Spratling, said that friends and family who attended college at Tulane, Tuscaloosa and Vanderbilt told her that students on those campuses who couldn't find the answer to a question would say, "I don't know. Let's call Foy."

Dean Foy died in October 2010 at age ninety-three. He was born on November 7, 1916, in Lexington, North Carolina, to Erle Humphrey Foy and Mary Lou Ware Foy.

Foy graduated from Auburn's biggest college rival, the University of Alabama. He worked five jobs while earning his undergraduate degree, including delivering the *Saturday Evening Post* and working as a butcher at the A&P grocery store.

One of his greatest contributions to the state came when he was an undergraduate at the University of Alabama. As president of the college's chapter of Omicron Delta Kappa, he organized a Better Relations Day between Auburn and Alabama and pushed to resume an annual football game between the rivals, according to the *Birmingham News*. The teams stopped playing over a minor conflict in 1907.

In 1948, the games resumed, later to be called the Iron Bowl because for many years they were played in Birmingham, the iron capital of the South. The James E. Foy–Omicron Delta Kappa Sportsmanship Trophy, which is bestowed each year on the winner of the Iron Bowl, is named in his honor.

Foy served as a fighter pilot in the U.S. Navy in World War II. He was awarded the Air Medal for Meritorious Service for his actions aboard the carrier USS *Suwanee* in the Solomon Island campaign. As executive officer of a fighter squadron attached to the Franklin D. Roosevelt carrier when the war ended, Foy had the honor of executing the victory fly-over of Washington, D.C.

In 1948, Foy was named assistant dean of men at the University of Alabama. He came to Auburn in 1950 to serve as assistant dean of men and was named dean of students in 1952. He served in that position until 1978. Dean Foy, who would marry Emmalu O'Rear, was widely known and beloved by students. He served on an array of boards, was involved in dozens of civic groups and was honored by numerous organizations.

During the Vietnam War, he was known for encouraging people to donate to blood drives, according to an article

James E. Foy served as a fighter pilot in the U.S. Navy in World War II. He was awarded the Air Medal for Meritorious Service. *Courtesy of Susan Foy Spratling.*

in the *Plainsman* written upon his death. In 1967, under his guidance, students donated 4,812 pints of blood in two days, an American Red Cross world record.

In 1975, Foy was named Outstanding Student Personnel Administrator by the National Association of Student Personnel Administrators.

When Foy was ninety years old, he asked to fly once again. Auburn alumnus J.B. Stockley obliged and flew the aging dean over the Auburn

campus and nearby Lake Martin on his birthday. The vintage plane was similar to ones he trained in during World War II. Foy is buried at Fairview Cemetery in Eufaula, where he grew up.

TAKE A RIDE IN THE SUPPER CLUB "SLUSH BUS"

After Taylor Hicks graduated from high school, he decided to attempt to fulfill one of his father's dreams and get a college education. The Birmingham native chose Auburn.

"When you think of Auburn, you think of southern college football. There's no metropolitan city attached to it. It's just thirty thousand college kids having fun on the plains in the heart of Dixie, and that's where I wanted to go," Hicks said.

He went from majoring in journalism, to psychology, to business and marketing, unsure of what he would do with his future. It was his relationship with an iconic Auburn landmark that helped Taylor decide.

Hicks, who would go on to win *American Idol* in 2006 and begin a successful recording career, was a regular performer at the War Eagle Supper Club while he was a student at Auburn, beginning at age eighteen, before he was allowed to buy alcohol.

The club is housed in a ramshackle building that, until the onslaught of recent development, was located on the rural outskirts of town. Its motto is stenciled on T-shirts, bumper stickers and even underwear: "Cold Beer. Hot Rock. Expect No Mercy."

Inside the walls of the club, which Hicks says "reeked of beer and nostalgia," the young musician received his real education.

"I was exposed to a true southern roadhouse at a very early age," Hicks said. "It gives you the exposure to be able to entertain all kinds of age groups."

After performing with a band for several years, he made his first solo appearance at the Supper Club. "It taught me a lot about the entertainment business and a lot about branding. I went from playing for about two thousand people a night with the band to playing to about fifty as Taylor Hicks."

In 2007, Taylor wrote in his memoir that while he garnered no accolades in academics, "inside the walls of War Eagle, I was a headliner."

He played his last gig there in 1998, to an overflow crowd, before he left college to seek a music career. When he returns to Auburn to attend football games, Hicks says he visits the club. "I expect cold beer, hot rock and I expect no mercy."

Were the Floors Ever Dirt?

The War Eagle Supper Club is so named because, throughout most of its history, it has remained a private club—by letter of the law, at least. This gave the club's owners privileges other owners of other college bars didn't have. The Supper Club could stay open and serve alcohol past 2:00 a.m. (often until 5:00 a.m.) and serve alcohol on Sundays.

It was this, combined with its ramshackle appearance and reputation as a breeding ground for musical talent, that has led to the lore that surrounds it. While some legends are untrue—the floors were never dirt, for example—many of the stories are based on history, said former owner Hank Gilmer.

Hank, who bought the club in 1977, said the original building on the site housed a brothel. When it burned in the early to mid-1940s, the existing club was built. Gilmer said the physical layout of the building supports the claims that a local law officer once played dice in a backroom with deputies while customers were "serviced" in a series of small, private rooms for a fee of $1.75.

About 1953, the building was home to Stoker's Steak and Seafood Restaurant. A businessman named H.H. Lambert cosigned the note with Homer Stoker, but Stoker ran the restaurant. The restaurant was open for about three years, but Homer eventually decided to move to Florida, leaving Lambert with a business to run.

Lambert took over in 1957 and created a pizza-and-beer joint. In 1961, at the height of the civil rights movement, he purchased a private club license. At the time, the Alabama Beverage Control board allowed white business owners to circumvent the law by purchasing a private club license. The owner then issued memberships for a nominal fee—to whites only, of course.

The Supper Club charged one dollar per membership. Black students weren't the only ones essentially banned from the club. At the time, female students were prohibited from frequenting establishments where alcohol was served.

The club was renowned for its secret-recipe pizza with a sauce that took two days to make, Gilmer said.

Early Days

One day in the 1950s, a single mom desperate for work walked into the Supper Club. Mildred Williams, who was about twenty at the time, told Lambert, "Mister, I need a job."

For the next three decades, the five-foot, two-inch Mildred was the club's unofficial "house mother," riding herd on rowdy students and ensuring that everyone stayed safe. "Mildred ran the War Eagle Supper Club for the next thirty years," Gilmer said. "If Mildred had ever seen your face or knew your name, she'd remember."

Former athletic director David Housel said Mildred loved her work at the Supper Club. "She enjoyed her camaraderie with the students. She knew when to let them have a good time and when to say, 'Hey, it's time to stop,'" he said. "I always thought of Mildred as the keeper of the Auburn spirit."

After Mildred retired, Gilmer hired her to come to the club on weekends and say hello to people. He paid her $100 per weekend as a greeter. It was Mildred who passed along the secret pizza recipe, and the story behind it, to Gilmer.

A year or so after she arrived to work at the club, there was a knock on the door after the club had closed. Lambert opened the door to an unidentified young man.

"He said, 'Mister, I go to Tulane, and I'm on my way home to see my family in New York,'" Gilmer said.

The young man said he hadn't eaten and asked for scraps.

H.H. Lambert fed him and offered to give him a ride to the north side of Opelika, where he could catch a bus. The student said he had no money but before getting out of Lambert's pickup truck, he scribbled down a recipe that his family used in a pizza restaurant.

"H.H. came back and gave the recipe to Mildred and said, 'Put it away,'" Gilmer said. At that time, H.H. had been serving food cooked on a grill placed near the open back door so smoke could escape. When the fire department notified him he would have to install ventilation, Lambert realized a pizza oven did not require a vent.

Mildred dug out the old recipe and tweaked it to create the club's famous pizza.

"It took two days to make the sauce," said Gilmer. "The dough was so thin you couldn't toss it." When Gilmer bought the club, he learned to make the pizza. But in the 1980s, pizza delivery businesses opened, and it was no longer profitable to make the difficult recipe.

"The last time I made it was in 1985," he said.

Gilmer still has Mildred's handwritten recipe.

When Gilmer purchased the club with his father, with Hank as managing partner, Hank had to meet requirements to obtain his own private license.

"The ABC board gave a wink and a nod to the private club license," he said. It was intended for organizations such as Elks lodges. "We always had an open membership policy for anyone who wished to join."

"I wanted it to be a private club so it could stay open late and make money," he said. Within a few years, Gilmer began providing live entertainment to draw more students.

At that time, students would leave campus and drive about ten miles down the isolated portion of South College Street to arrive at the club. All bars were several miles from campus then.

"Prior to 1975, it was illegal to serve alcoholic beverages within one mile of an institution of higher learning," Gilmer recalled.

Because it stayed open so late, students chose it as the last stop of the night, often not forming a line outside until after 11:00 p.m. The problem was that students would also need to drive back to their apartments and dorms, a dangerous proposition after imbibing. Gilmer said he was alerted to the fact that law officers would be watching for drunk drivers.

"There was nothing between the Supper Club and town, so the officers knew nine out of ten people headed to town came from the Supper Club."

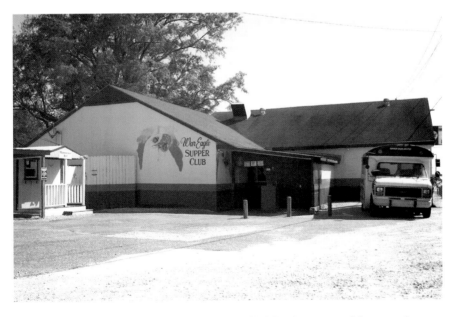

The building that houses the War Eagle Supper Club has been around for more than six decades, once housing a brothel and later a seafood restaurant. These days, the ramshackle building is a popular nightspot where students go for live entertainment. *Photo by Rebecca Croomes.*

Gilmer had some friends in California who had developed the "Friends Don't Let Friends Drive Drunk" campaign and came up with a way to encourage students to be safe.

He bought an old school bus to drive students home. Riding in the "slush bus" would become a rite of passage for thousands of Auburn students.

Brushes with Fame

In the 1980s, Auburn student John Brandt began working at the club a couple of nights a week as a doorman. Before long, he was working additional nights and became a bouncer, bartender and manager. When Gilmer was ready to retire, Brandt bought a portion of the club, which he now owns with partner Mark Cadenhead.

Brandt recalls many of the musicians who have passed through its doors and whose photos adorn the walls.

"We get a lot on the way up and a lot on the way down," he said.

Lou Diamond Phillips and River Phoenix performed with their bands. Popular groups Widespread Panic, Drivin' and Cryin' and the Zac Brown Band played at the club in their early days.

Kenny Chesney once played a benefit concert there, and David Allen Coe performed his famous song, "You Don't Have to Call Me Darlin, Darlin'."

In 1992, a thirteen-year-old guitarist named Derek Trucks performed on the Supper Club stage.

"We were like, 'Oh my God, this kid's amazing,'" Brandt said.

Trucks formed his own band at age fifteen and would go on to play with Eric Clapton and the Allman Brothers. Famous athletes such as Charles Barkley and Bo Jackson have also frequented the bar, but usually after their careers at Auburn ended.

Tracy Rocker, two-time All-American while playing at Auburn and defensive line coach for Auburn during its 2010 championship run, worked at the club as a bouncer during his student days. One night, just as members of the band Telluride were packing up to leave because it was a slow night, Larry Linville, who played Frank Burns on *M.A.S.H.*, arrived. Band members pulled out their instruments and played for Linville.

"They got him up onstage with a tambourine," Brandt recalls. In 1997, *Playboy* magazine named the club on its list of Top 50 College Bars.

Gilmer added the front stage area, known as the pit, in 1982 so that students could stand near the stage and sing along with bands. Concrete floors with drains were installed so the floors could be hosed down after students left for the night.

Brandt kept most of the club's legendary features—it has the same floors and restrooms covered by plywood doors with hook locks—and has added some new ones. The retired "slush bus" was attached to the back of the building and made into a shot bar in 2007, becoming one of the businesses four bars. Alumni come in and order drinks and relive fond memories, Brandt said. The club offers a more modern van as transportation home these days.

To the students who passed through its doors, the flimsy cards issued when they became members of the War Eagle Supper Club are prized possessions. Kristin Lloyd, class of 1986, recalls her panic when she lost her purse in Birmingham after graduating. Her driver's license and credit cards were gone. When she called her friend Tammy Harris to tell her of the loss, only one item came to mind. "My Supper Club Card is gone," she wailed. Lee Andrews said that he and his brother, Mike, once frequented the club, which is now the stomping ground of a new generation of students, including Mike's sons. They like to point to a scribbled saying on the club's wall and tell their friends, "My dad wrote that in the 1980s."

In 2004, while in Auburn covering the football team's winning streak, ESPN analyst Chris Fowler wrote of visiting the Supper Club: "Auburn had better stay near the top. GameDay wants to go back, soon and often."

ROCK 'N' ROLL AND MOMMA'S LOVE

By the mid-1970s, sales were declining in Don DeMent's men's shop. The Locker Room on Magnolia Street in Auburn sold button-down shirts, penny loafers and Izod belts to college students. The problem was, students seemed to be moving toward an era of drugs and rock 'n' roll and were mostly wearing jeans and T-shirts.

So DeMent decided to change gears and create something every college student needed—good, comforting food. In 1976, Auburn was home to only one ethnic restaurant—selling Mexican food—and DeMent, a Gentile, decided he wanted to open a kosher deli.

"You could get hamburgers, or meat-and-threes at boardinghouses," DeMent says. "I was looking for something a little different that would attract students."

DeMent, who graduated from Auburn University in 1963 with a business degree, didn't want to have to install a kitchen in his store on Magnolia, so he decided to buy his meat ready-to-serve and offer "Jewish-type food."

Then he was faced with a problem: how do you sell Jewish food from a place called DeMent's? Scouting for a Jewish-sounding name, DeMent recalled a former boss from Pizitz department store in Birmingham, where he'd worked not long after he'd graduated from college. Chester Goldberg was the type of businessman DeMent wanted to be: honest, hardworking and respected. "He had a work ethic and moralistic view I embraced," DeMent said.

Don was raised by parents with this same work ethic. He was born in Shelby County in 1939 to Jack, a coal miner, and Blanch, who taught sewing.

After settling on the Goldberg name, DeMent had another challenge. "I realized there were probably only eight or ten Jewish kids in school at Auburn at the time, and I would be selling to Gentiles," he said. DeMent decided to call his deli Mama Goldberg's, because "mama" was a word that would sound comforting to college students. "I put 'mama' in there because kids start thinking lonely thoughts and start thinking of mama. Mama is a very comforting thought."

However, when the sign was made by Don's brother, Mike, it was spelled "momma," and Momma Goldberg's was born.

Brothers Don and Mike DeMent at the original Momma Goldberg's Deli on Magnolia Street, which still operates today. *Courtesy of Mike DeMent.*

The first Momma Goldberg's opened in 1976, selling a variety of sandwiches prepared with meat DeMent ordered from a kosher processing house that he still uses today.

"There's no stove, no cooking. I felt that was the best way to maintain a consistent product," DeMent says. "That was key to me. I'm a quality-oriented person."

That consistency is what kept college students coming back. DeMent offered more, though, than food. He wanted his store to be a place kids came to enjoy themselves.

"People took Auburn students for granted here, thought they were in the way," he said. "But I embraced them. I'd go to frat houses and set up food for them and have parties in the store. When other places didn't allow checks or made students show ID, I would accept checks with no ID. We're very student oriented, and I think that's why students felt that love."

In the 1998 *Glomerata*, a student wrote of passing time by playing darts at the deli. Fraternity brothers would meet there to eat before football games. Students began calling the deli "Momma G's."

"There's a warm fuzzy feeling about Momma Goldberg's," DeMent says.

When the deli first opened, DeMent offered an array of choices of meats, breads and cheeses, and the students would choose their favorites. But

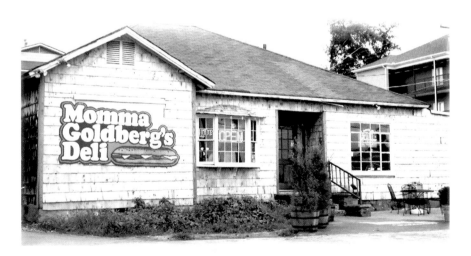

Momma Goldberg's Deli opened in Auburn in 1976. The kosher deli was the brainchild of Don DeMent, a Gentile. *Courtesy of Mike DeMent.*

DeMent says in the late 1970s and early 1980s, sometimes drugs and rock 'n' roll left students too dazed for sandwich making.

"So I made a listing of favorites they had put together and gave them names," he said. That's when Momma's Love, the deli's signature sandwich, was born. The sandwich—with roast beef, ham, smoked turkey, Muenster cheese, lettuce, tomatoes, mustard, mayonnaise and Momma's dressing—accounts for 65 percent of sales. "People even call me Momma's Love."

The original deli at the corner of Magnolia and Donahue is still open. It is the oldest independently operated restaurant in Auburn.

Today, DeMent offers franchises of the deli. Sixteen have opened—including three in Auburn and one in Opelika—and twenty-two more are under contract to open. All but one is owned by Auburn graduates.

"We have stores in most of the SEC towns," he said.

Chester Goldberg, who had learned through relatives who visited Auburn that he inspired the name, died in May 2010 in Birmingham.

J&M: THE JOHNSTON FAMILY LEGACY

After serving in World War II, George Johnston Jr. returned home to Lee County and, like hundreds of other young men, enrolled at Alabama Polytechnic Institute on the GI Bill.

George, the son of Walter George Johnston Sr. and Cherry Bell Johnston, was born in 1923.

While enrolled at API, George met a woman who had all the men on campus buzzing: Dorry Ann Hayes. Dorry was named a Sigma Chi sweetheart in her freshman year in 1948 and was Miss Auburn in 1949. She never wanted for dates, often having a different escort for lunch and dinner in the same day.

Tom Eden, who was head cheerleader and president of the senior class at API in 1949, said Dorry Ann was quite popular on campus, especially on a campus where men outnumbered women eight to one.

"She was involved in a lot of activities," Eden recalled. "She was not only pretty but sweet and lovely and a wonderful person."

George was the man who captured her heart, and her hand.

Dorry left college to marry George in 1951.

In October 1952, Walter George Johnston III, or "Trey," was born, but not before a frightening episode in which Dorry fainted—either from excitement or exertion—at Toomer's Corner during a celebration following

a football victory when she was about eight months pregnant. The Johnstons would later have another son, Skip, and a daughter, Dixie.

George soon was given the opportunity to secure his family's future when Paul Malone of Tuscaloosa asked him to become a partner in an off-campus bookstore. It had previously been called Malone's and was later owned by the Hawkins family, when it was known simply as Hawkins Bookstore. When the owner of the Hawkins store died, Malone said he would buy the store if George would run it. The men became partners, and the store on College Street became Johnston and Malone Bookstore on May 19, 1953.

In the 1960s, Johnston purchased Burton's Bookstore, located on the same block of College Street, which had been in Auburn since the 1879.

George bought Paul Malone's half of the business in 1960 and renamed the store J&M. Ownership was divided among George, his brother Harvey and George's children.

Malone, who still owned the College Street building from which J&M operated, also owned bookstores on campuses throughout the South, including in Tuscaloosa, Memphis, Atlanta and Tallahassee, Florida. Malone was known as a gambling man, Trey Johnston said, and he made a fateful decision one night in 1963.

"Mr. Malone lost the real estate portion of the business in a poker game," Trey said. "I'm still writing a check to the people in Tuscaloosa who won the bet. I guess he just had the deed in his pocket and he bet it."

Brothers Harvey and George Johnston took over the Johnston and Malone store after Paul Malone died. They changed the name to J&M bookstore. *Courtesy of Trey Johnston.*

Legendary Auburn quarterback and Heisman Trophy winner Pat Sullivan poses with Hazel Johnston Lee (left) and Dorry Ann Johnston Blackburn. Dorry Ann was named Miss Auburn in 1949. *Courtesy of Trey Johnston.*

In the 1960s and '70s, the Johnston family owned several other stores in Auburn and on other campuses in the South.

A tragedy would change the fate of the business empire. On a lark, Harvey went for a ride in a World War I airplane with a friend. The plane crashed, killing Harvey instantly.

The store ownership was divided among George and his sons, Trey and Skip, and Harvey's son, Scott, and the family would keep only two stores open in Auburn.

Over the years, J&M became a landmark in Auburn and is packed on game days with visitors buying souvenir items.

Trey had attended Auburn in the 1970s to major in business but left college when his uncle died to help run one of the family's stores.

Skip, who would graduate from Auburn in 1980, was a punter who played on Auburn's team with William Andrews and James Brooks. An article in the *Times Daily* in Florence in 1979 said of Skip: "It isn't often that people speak

first of what a nice guy, a good individual, a real gentleman a person is, when that person is also one of the finest punters in the Southeastern conference."

Dixie broke with family tradition and attended the University of Alabama, where she met star quarterback Robert Fraley, whom she would later marry.

Another tragedy struck the family when Robert died in 1999 in a plane crash that also killed famed golfer Payne Stewart. Fraley had become a sports agent and was working for Stewart at the time. Officials determined the plane had lost pressure, and those aboard had died from lack of oxygen before the plane finally ran out of fuel and crashed in South Dakota.

George Johnston died on April 29, 1997, leaving the store to Trey and Skip and their cousin Scott.

"We have been blessed with a wonderful business and a wonderful relationship with the university," Trey said. "We're here because of the university, and we always remember that." In return, the Johnston family has endowed several scholarships, including one that goes to children of former bookstore employees.

Notable and Notorious

THE REAL ROBIN HOOD

Auburn students have completed some amazing feats over the years. Everyone knows Bo Jackson could leap a pile of Tide players in a single bound and Cam Newton could, well, fly. Only one graduate can lay claim to the title "World's Greatest Archer." He's the only man who could split an arrow with a second arrow: Howard Hill.

Born on November 13, 1899, in Wilsonville, Alabama, Hill not only became the best bowman of his time, but he also was a film double for Errol Flynn and helped develop archery golf. Before graduating in 1923 from Alabama Polytechnic Institute, Hill lettered in football, baseball and basketball. In his spare time, he practiced his archery and played a mean game of golf.

When Hill set out into the world, he didn't choose any of the traditional sports he played in college. He chose archery and soon was winning tournament after tournament, eventually setting a record for winning 196 straight competitions.

He mastered dozens of mind-boggling trick shots, such as shooting a plum or apple from someone's head from a distance of sixty feet. Hill was known as one of the strongest archers, able to pull bows with 170 pounds draw-weight. He designed and made his own longbows, preferring bows without sights.

Soon, he was starring in movie shorts, and although considered rugged and handsome, Hill chose a career as a movie double. He doubled for Flynn in all his movies in which archery was required but is most known for his

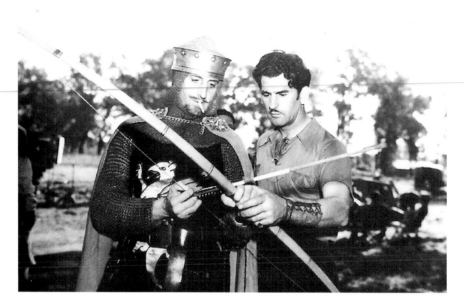

Howard Hill, who graduated from Alabama Polytechnic Institute in 1923, was the world's best archer and doubled for Errol Flynn in numerous films. In this photo, Hill is seen with actor Basil Rathbone (left) on the set of *The Adventures of Robin Hood. Courtesy of Howard Hill Archery.*

role in the 1938 film *The Adventures of Robin Hood*, when he made the iconic arrow-within-arrow shot.

The shot has never been replicated with wooden arrows, although the TV show *Mythbusters* attempted it.

An article in the June 26, 1938 edition of the *Tuscaloosa News* announcing the showing of *Robin Hood* at the Bama Theater gave glowing accounts of Hill's skills:

> *It was Hill who was the "real" Robin Hood with the strong bow and the perfect arrow, for he is the world's champion archer and doubled for Errol Flynn and for other characters in schemes calling for unerring shots for which Robin was so famous. Hill's marvelous skill with the bow and arrow astounded Hollywood itself, which is accustomed to marvels.*

The article recounts Hill's childhood in rural Shelby County, where he learned archery "playing Indian" on the farm. During summer vacations from college, Hill would give archery lessons to earn tuition to return to school in the fall. His classmates called him "Cupid."

The *Tuscaloosa News* story ends:

> *Alabama movie goers will find Howard Hill a native son who has won the admiration and acclaim of filmland itself. Popular with the cinema industry, he resides in Southern California and makes high-grade archery equipment, as well as teaching the sport and occasionally winning golf and archery championships.*

Hill also would produce, direct and star in documentaries on bow hunting and archery, which included trick shots such as shooting an arrow through a flipped coin from a distance. In 1952, the *Auburn Plainsman* featured a story by Charles Sullivan about Hill returning to Auburn to promote *Tembo*, a documentary about bow hunting.

The story stated:

> *During Hill's football days, Auburn was a national gridiron power under the tutelage of Head Coach Mike Donahue. "What that Howard Hill does is as unpredictable as the next leap of a scalded cat or tin-canned dog," Coach Donahue said one afternoon during a practice scrimmage when the rangy end caught a pass then veered sharply from his path to the goal in order that he might run down the opponent's safety man.*

Tembo, an RKO movie, was filmed in Africa, where Hill hunted big game—including a python and an elephant.

> *In reminiscing about his varied career, Hill recalls his football playing at Auburn as being more exciting than many of his hunting escapades. But he says the greatest thrill was knocking over the elephant in* Tembo *which gets its name from the native word for elephant. Hill is the only white man ever to kill either a boar or an elephant with an arrow.*

Howard Hill was inducted into the Alabama Sports Hall of Fame in 1971. He ran a small archery equipment shop in Vincent, Alabama, and the resulting company—Howard Hill Archery—is still run by friends from its headquarters in Montana.

Hill was married to Elizabeth Hodges of Ashville, Alabama, from 1922 until his death in 1975. He is buried at New Ashville City Cemetery beneath a marker etched with two bows and arrows.

NO LONELY KNIGHTS FOR TONI

In the late 1950s, pretty, blond, eighteen-year-old Antoinette was spending late nights with a group of men, riding to various nightclubs in a converted Cadillac hearse that had been painted pink. Her actions would have been unseemly for the era had it not been for the fact that young "Toni" was the "chick singer" for the swing band the Auburn Knights Orchestra, and she was loved and protected by the men, who appreciated her sultry contralto.

Toni had inherited her love of music and performing from her father, Frank Tennille. She also inherited another love from her dad: a love for Auburn University and the Auburn Knights.

Toni Tennille, born in 1940 in Montgomery, would go on to be one of the band's most famous alumni, recording numerous pop hits with her husband, Daryl Dragon, as the duo The Captain & Tennille.

Toni entered Auburn in 1958.

"My mother had visions of girls' schools like Smith," Tennille said in a recent interview. "Daddy said, 'No, she's going to Auburn.'"

Frank had attended Auburn and was in the Auburn Knights in 1930, the first year it was formed. He would later find notoriety as a big band singer.

"Daddy was a wonderful singer. He was with the Bob Crosby Orchestra."

Her father played under the pseudonym the Clark Randall Orchestra in the 1930s. When Frank's father died, Frank left show business to return to Montgomery to run the family's business, the Tennille Furniture Store. Toni said that leaving music was difficult for her father, but at the time, family responsibility came first.

Frank would marry Cathryn, and the couple would have four daughters—Toni, the eldest, and Jane, Louisa and Melissa—all of whom would be taught the art of singing and a love of music by their parents. Cathryn was musical and also a performer; she was the host of Montgomery's first television talk show.

"All four daughters came out with nice voices," Toni said. "We used to harmonize and sing. Mother played piano. I started taking piano lessons when I was seven years old." Frank also would bring home albums of the biggest hit makers of the day, teaching his daughters about a variety of music styles.

"He'd say, 'Wait till you hear this.' That was our music education. Music was very, very important in our house," Toni said.

The Auburn Era

The photo in the 1959 *Glomerata* shows a ponytailed Toni Tennille with her trademark broad grin looking much the same as she does today at age seventy. The previous fall, Toni had moved into one of the women's dorms and became one of the protected, supposedly "weaker sex" on campus.

"There weren't many women on campus yet when I became a coed," Toni said. "There were about four guys for every girl. We had housemothers at the dorms, and we had to check in each night. Heaven forbid we had alcohol on our breaths, which we didn't because girls didn't do that then."

Toni and her female classmates were not allowed to wear pants on campus. The typical "uniform" was a straight skirt, a sweater with a lace collar, a string of pearls and saddle Oxfords. Blue jeans were forbidden.

"The only time you saw a woman in jeans was when she was getting in the car to go home or headed to the lake," Toni said.

Women were required to live in dorms on campus, but Toni tried the patience of the housemother. "We would be performing late, and I'd have to wake up the security guy, who would wake up the house mother to let me in. She didn't like it."

Toni and a few other women finally received special permission to live in an apartment off campus.

"The only heat was a little open-face gas heater. I'm surprised that place didn't explode," she said. She no longer was required to check in with anyone and would hop into the pink Caddy hearse, refurbished with seats in the back, and head to gigs with her band mates.

"I was what was known as the 'chick singer.' I would sit beside the band in my little chair, and when I was supposed to sing, I would get up and sing, then sit back down."

She credits the Knights with teaching her to improvise. "The Auburn Knights were straight, big band jazz. I was a classically trained musician. I didn't know how to improvise." Swinging, she said, is an indefinable thing—knowing when to lay back on the tempo and work around the rhythm. Under her friends' tutelage, she learned she was a natural.

She could read music, but with the Knights, she learned chord symbols and other skills that helped when she began writing her own music. "I have to thank those guys from the Auburn Knights."

Toni was dating the vice-president of the same fraternity her father had pledged and recalls that game days were more formal occasions.

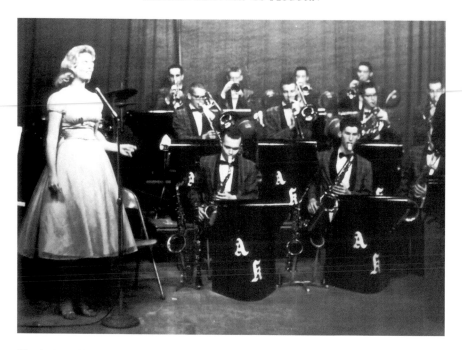

The Auburn Knights Orchestra has produced many excellent musicians since 1930. One of its star singers, Toni Tennille, went on to a successful career as a recording artist and in television. *Courtesy of Auburn University Libraries.*

"We'd go to the fraternity house, where the housemother watched over us. We would be wearing suits and dresses with little coats and high heels and corsages. We'd have a lovely lunch and then go to the ballgame."

As a member of the Women's Jazz Octet and the Concert Choir, Toni got university credits, but the Auburn Knights Orchestra was a separate entity from the college, created at a time when such bands played for dances and swing was in full swing.

After being formed in the fall of 1930 by Jimmie Robbins and J.R. Quinlivan, the Knights were instantly successful, acquiring two booking agents. Music Corporation of America, which booked the most famous bands in the country, booked the Auburn Knights for summer-long engagements during vacations from school. According to a history of the Knights at auburnknights.com:

> *The Knights were popular not only with the listeners and dancers but also with the professional musicians who came to the club on their night off to listen and sit in with the big band from Alabama. Sometimes these sessions*

would last after hours or until daylight. The highlight of the 1941 summer trip was when Tommy Dorsey and side men Don Lodice, Ziggy Elman, Buddy Rich and Frank Sinatra sat in with the Knights.

Before the Captain

Toni declared as an English major with a minor in music. She had no clue what she intended to do with the degree, but she knew those were the subjects she enjoyed. "Most women didn't plan on careers. They went to find a husband. I pictured myself teaching poetry and literature, and I thought I would figure it out as I went along."

There was one glitch in Toni's plan: physics.

"I had to have physics to get my degree, so in my sophomore year, I decided I was going to try to pass this course called dishwater physics. It was physics for stupid people," Toni said with a laugh. The course was held in a building with theater seating in which about one hundred students stared down at the professor in the front of the room.

"All I could hear was 'drone, drone, calories, drone,'" she said. "I decided that was enough of that."

As it turned out, Toni wouldn't need the physics course. When her family moved from Montgomery to California in the summer of 1960, she followed them, expecting to return in the fall to start her junior year at Auburn.

"I did intend to come back," she said. "A couple of the guys from the Auburn Knights flew out to California and said please, please come back. I was so touched."

Instead, she began work at North American Aviation as a typist and clerk. She would stay for several years, eventually becoming a receptionist in research and development, a position that required a level of security clearance second only to the president of the United States, she said.

"I had clearance from the U.S. Secret Service," she said. "I'm sure there's a file on me somewhere, but I hope it's a good one."

In her spare time, Toni performed in musicals and continued to sing. She wrote the musical *Mother Earth*.

The course of her career was forever changed, though, when she met a man named Daryl Dragon in 1972. Daryl was playing with the Beach Boys, and Toni got a gig that summer playing keyboards, becoming the one and only "Beach Girl."

She and Daryl formed The Captain & Tennille and were married in 1974. The duo would have numerous chart toppers, including "Shop Around,"

"Lonely Nights (Angel Face)," "Do That to Me One More Time" and "Muskrat Love." They won a Grammy for "Love Will Keep Us Together" in 1975.

In 1976, *The Captain & Tennille Variety Show* debuted on television. Toni's sisters performed on the show, as well as on Captain & Tennille albums. Toni hosted a talk show in 1980, *The Toni Tennille Variety Talk Show*.

Tennille also sang backup vocals for some popular performers of the 1980s. She sang on Pink Floyd's *The Wall*, and she also sang for Elton John on several of his albums, including the hit "Don't Let the Sun Go Down on Me."

When the hits slowed in the mid-1980s, Toni returned to her first love: jazz and pop standards. She sang on several albums produced by Daryl, such as *Incurably Romantic*, *More Than You Know*, *All of Me*, *Moonglow* and *Tennille Sings Big Band*. The tracks included renditions of songs by composers such as George Gershwin, Hoagy Carmichael and Irving Berlin.

When she toured, she performed an old standard, "Happiness Is a Thing Called Love." The sound mixer played the first eight bars of eighteen-year-old Toni singing the song with the Auburn Knights, and she would segue into

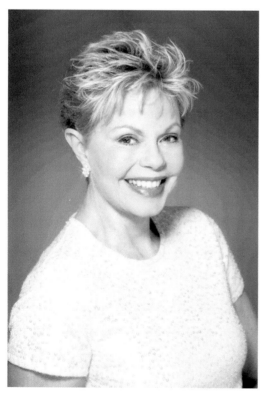

Toni Tennille at age seventy in 2011. *Courtesy of Toni Tennille.*

her live performance. Recordings of some of Toni's hits with the Knights are available on a CD called *Happy*.

The Auburn Knights Orchestra continues to perform today. The group has reunions, and in 1980, Toni returned to Auburn for a reunion and to perform two concerts the night before the A-day spring practice game. Some of the proceeds went to establish the Toni Tennille Scholarship for Jazz Studies.

Toni was discussing the rigid standards for women when she was in college and commented on her return visit, "When I went back, here are these girls lying outside in front of dorms in teenie-weenie bikinis."

Today, Toni and Daryl live in Arizona, where a friend of Toni's is trying to convince her to sing karaoke to "Love Will Keep Us Together" in a local joint. So far, she has refused. But she did perform a concert for the town last year and hopes to give another one.

Toni and her dog, a trained therapy canine, also visit patients at the local hospital each week.

BOBBY GOLDSBORO'S GOLDEN OPPORTUNITY

It was a chance meeting with a music legend that changed one young Auburn student's path in life.

In the summer of 1961, when Roy Orbison was celebrating another Top 40 hit with "Cryin'," the iconic singer fired his entire band when he caught the musicians drinking. With four dates to play in the Southeast and desperate, Orbison asked a promoter to find a new band.

The Webs, a fledgling group that had been playing clubs and dances around Auburn for two years, got the job.

"It wasn't that we were so good, we were just the only band around that area," said singer Bobby Goldsboro. "So we got the call. We learned his songs as well as possible for four guys, since he had full orchestration on all his recordings."

Goldsboro, who had spent his youth dreaming of playing professional baseball, had realized upon entering Auburn in 1959 that it wasn't an option. At a mere 128 pounds, he didn't have the size.

So he enrolled in the College of Business Administration and turned to another love: music. While a student at Dothan High School, Goldsboro had picked up a ukulele that belonged to a friend on his street and began to play.

"He couldn't play it so he gave it to me," Goldsboro recalled. That Christmas, Goldsboro received a guitar, which he took with him to Auburn, and joined a group called The Webs.

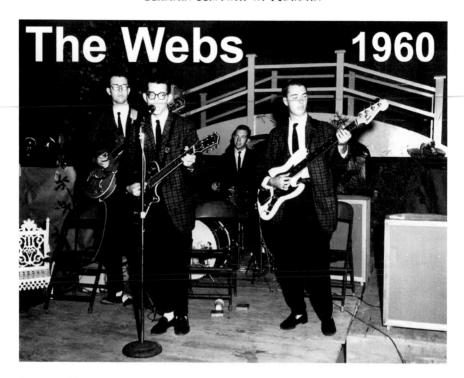

A teenaged Bobby Goldsboro sings with the band, The Webs, at Auburn University about 1960. *Courtesy of Bobby Goldsboro.*

"We had black shirts, black pants and white ties with spider stick pins. Yeah, we were cool," Goldsboro recalled. "We played fraternity and sorority parties every weekend at Auburn, Florida State and even (gulp) the University of Alabama. I don't remember the names of the clubs, but if there was one within one hundred miles of Auburn, we probably played it."

The group played tunes popularized by the Ventures as well as blues.

"We also did a lot of blues—Jimmy Reed, John Lee Hooker, Lightnin' Hopkins, etc. We were white guys doing black music. Maybe we started something," he said. In Goldsboro's freshman year, The Webs won the university's talent show. The band also worked with other musicians.

"The Webs backed up several artists while I was at Auburn who already had hit records: Bruce Channel ('Hey, Baby'), Ray Peterson ('Tell Laura I Love Her'), guys like that."

During his sophomore year, Goldsboro was noticeably losing interest in his studies.

"I pretty much went through the motions in class. I realized by my second year that I had a better future in music than anything else. Plus, it was fun and I was making money."

The relationship with Orbison gave him an unexpected opportunity. "Roy and I just hit it off immediately," he said.

> *We became like brothers over the week that we worked with him. After the last show, Roy asked us if we'd like to go on the road as his band. I never came back to school. I played guitar for Orbison from 1961 to 1964. It really wasn't a tough decision at all, except telling my parents. I said, "I can finish school and still not know what I'm going to do or I can go on the road with one of the biggest names in music." So, I went on the road with Orbison. Shortly after that, I flew with Roy to England to do a two-week tour with The Beatles.*

Goldsboro began a solo career in 1964 by recording the first of his sixteen Top 40 hits, "See the Funny Little Clown."

One of his first concert appearances was as the opening act for the Rolling Stones during a U.S. tour. In his book, *Life*, Keith Richards recounts how Bobby showed him an especially tricky chord known as the Jimmy Reed 5.

An opportunity to tour with Roy Orbison led Bobby Goldsboro, shown in 2011, to leave college and begin his music career. *Courtesy of Bobby Goldsboro.*

Richards wrote that he'd always wondered how to play the chord, and Bobby, who had worked with Jimmy Reed, showed him on a bus somewhere in Ohio.

Goldsboro began churning out hits, reaching the Billboard charts with twenty-nine consecutive singles. In 1968, he released his hit "Honey," and in 1971, "Watching Scotty Grow." He has received twenty-seven Broadcast Music Inc. awards, hosted a nationally syndicated television show from 1973 to 1976 and received the BMI award in 1993 for the theme song for the TV show *Evening Shade*.

Goldsboro was inducted into the Alabama Music Hall of Fame in 1999. These days, he travels the country giving showings of his oil paintings. Bobby says he'll never lose his love of Auburn.

"I haven't been back, but it's not because I didn't love Auburn," Goldsboro says. "It was the first time I was ever on my own, so to speak, and I did a lot of growing up in those two years. I still follow Auburn wherever I go. My whole family lives and breathes Auburn football."

KIRK NEWELL: SMALL PACKAGE, BIG PUNCH

The year was 1913. The ruggedly handsome Kirk Newell, whose senior yearbook required several pages to discuss his accomplishments, was captain of the Alabama Polytechnic Institute football team.

His achievements on the gridiron belied his small stature and a weight of only about 150 pounds, but Kirk's heroics extended beyond Auburn and the football field.

He was also a much-decorated hero of Word War I.

James Kirk Newell was born on November 4, 1890, in Dadeville, Alabama, the sixth of seven children of James Wesley Newell and Mary Ella Wise Newell. His parents lived to see his successes. His father died in 1930 and his mother in 1932.

At API, Kirk was an all-around athlete. He lettered in football and baseball all four years and in track, "soccer football" and basketball each for one year. He also played tennis for API and golf in his spare time.

On the football field, no one could stop Kirk Newell. He was a halfback who, during his four-year career, would gain 5,800 yards rushing, 350 passing and 1,200 in punt returns. He was known for making quick changes to avoid tackles.

During his four years, API's record was twenty-four wins, four losses and two ties.

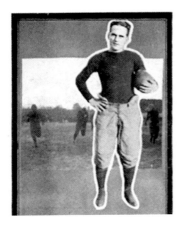

VARSITY FOOTBALL TEAM
Champions of the South

NEWELL
Captain and All-Southern Halfback

Captain Kirk Newell leader of the Southern Champions proved to be the sensation of the South as a broken field runner. At all times heady and ready to take advantage of any slip by the opposing team, his directing of the attack was all that could be desired, and it would be useless to comment further on his skill in carrying the ball, so unanimous is the opinion that he was the best in the South. He was unanimously chosen for All-Southern and

This photograph from the 1914 *Glomerata* shows Kirk Newell, captain of the 1913 championship team. *Used with permission. Auburn University Libraries.*

In 1913, Newell gained 1,707 yards, 44 percent of the team's total.

That championship season, Kirk Newell, along with legendary coach Mike Donahue, would lead Auburn into the history books and the first national championship ever won by a Southern university. Previously, only Ivy League and northern colleges had won football championships, as recorded by the Billingsley Report.

API was awarded the national title retroactively by several computer rating systems, including the College Football Research Center, a component of the BCS.

Auburn played eight games in 1913 and went undefeated: against Mercer, 53–0; Florida, 55–0; Mississippi State, 34–0; Clemson, 20–0; LSU, 7–0; Georgia Tech, 20–0; Vanderbilt, 13–6; and Georgia, 21–7.

The *Atlanta Constitution* reported the championship win in November 1913: "The orange and blue of the Alabama Polytechnic Institute at Auburn, Ala., today waves triumphant over all the gridirons of the Southern Intercollegiate Athletic Association."

Vandy and Georgia were the only two opponents to score on Auburn for twenty-three straight games over the course of the seasons when Newell played or coached at API.

The *Official National Collegiate Athletic Association Football Guide*'s 1945 rulebook said Newell was "one of the greatest broken field runners of all time, with two or more runs of 35 yards or more each in every game, including one of 90 yards in the Georgia Tech match."

In the 1914 *Glomerata*, Kirk's classmates voted him Most Popular Athlete. The *Glom* stated:

> *Once more our great little captain and halfback, Kirk Newell, was voted the most popular athlete in school. While he was leading his team to the SIAA Championship, he was also winning a larger and larger place in the hearts of Auburn boys. He is one of the best football and baseball players in the Southern, besides being a star basketball and track man.*

Under his senior description in the same *Glomerata* was written:

> *Captain Kirk Newell, leader of the Southern Champions, proved to be the sensation of the South as a broken field runner. At all times heady and ready to take advantage of any slip by the opposing team, his directing of the attack was all that could be desired and it would be useless to comment further on his skill in carrying the ball, so unanimous is the opinion that he was the best in the South. He was unanimously chosen for All-Southern and mentioned for all-American. Old football men declared him to be the greatest back that ever trod a Southern gridiron.*

A report on the death of Kirk's mother in the *Tuscaloosa News* on September 21, 1932, illustrated the lasting impact he had on college football:

> *Auburn sports lovers of almost a quarter of a century will experience a feeling of sympathy…in the death of his mother, Mrs. J.W. Newell of Dadeville. Newell weighed only 150 pounds with his cleated shoes on. In his senior season, Newell captained the all-Southern eleven, probably the lightest man ever to hold that honor, in the day of heavy football teams. There are Southern football fans who contend that Newell is an all-time all-Southern quarterback no matter how much longer the game is played.*

Immediately upon graduating, Newell would coach API's football team. He left the position in 1916 to fight in the World War I.

The 1932 *Tuscaloosa News* article reported, "In the World War, he saw active service and received severe shrapnel wounds to the body when a hand

grenade exploded during practice in a trench. He did not have time to use his great football passing arm and hurl the grenade back into the open."

In a retrospective of sports stars turned war heroes on December 1, 1947, the *Schenectady Gazette* reported:

> *And there is Kirk Newell, who could hide his scarred chest under the medals awarded him for his heroism in the first World War. Newell, famous as a scat back at Auburn, won't talk about it, but he saved the lives of about eight fellow soldiers by throwing himself on a live grenade. His grave wounds brought months in hospitals.*

He was awarded the Distinguished Service Award for heroism.

Kirk remained active when he recovered from his wounds. On March 20, 1918, Kirk married Ruby Rosiline Rogers. He returned to Auburn to coach football from 1922 to 1925. When he was not coaching, the pharmacy graduate worked as a drug supply company representative.

He also is credited with organizing and building the first golf course in Auburn and was an active Boys Scouts leader. He died on January 15, 1967, and was inducted into the Alabama Sports Hall of Fame in 1994.

THOM GOSSOM: RELUCTANT BARRIER BREAKER

During Auburn's storied 2010 championship run, standout quarterback Cam Newton would leap into the stands after each victory and celebrate among the students. His wide grin and vivacious personality earned him the love of his fellow students as much as his prowess on the football field earned their respect.

Thomas Gossom Jr., one of the men who paved the way for black athletes like Bo Jackson and Cam Newton, was struck by something else: no one seemed concerned about color. Young white women were holding signs reading: "Marry me, Cam."

In addition, many of the teammates who helped win Auburn's championship, along with some coaches, were black.

"It was a wonderful thing to see for Auburn," Gossom said. "They celebrated at a level that moved beyond skin color. Cam Newton was a milestone for Auburn, even more so than Bo."

Gossom helped make that possible.

In 1975, he became the first black athlete to graduate from Auburn University. He was one of three black athletes at Auburn at the time, including

In 1973, Thom Gossom Jr. (right) and James Owens were the only two African American players on Auburn's football team. *Courtesy of wareaglereader.com.*

James Owens, the first African American to play football at Auburn, and Henry Harris, a basketball player who was the first black athlete to receive a scholarship.

The first black non-athlete student, Samuel Pettijohn, graduated from the university in 1967, and by the time Gossom arrived from a Catholic school in Birmingham, about thirty African American students were enrolled at Auburn.

Gossom arrived on Auburn's campus in 1970 with a dream of playing football but no spot on the team and no scholarship. He became a "walk on."

After that first season, Gossom received his scholarship and was starting wide receiver for legendary coach Shug Jordan for the next three years.

While some strides had been made since integration began, Gossom and the others were charting new territory.

Harold A. Franklin had become the first black student to attend Auburn in 1964.

"At the time, Dr. Draughon gathered everybody in the stadium and told them Auburn had been forced to integrate, and they didn't want to have any incidents," said Gossom, who researched Franklin's experience. "The night he

arrived, the Justice Department was there with a phone in the car so they could call the president of the United States in case anything happened. The next day, ninety-nine state troopers escorted him from Montgomery to Auburn."

Gossom said that although Franklin was accepted at the university, he was isolated. "He was housed in a wing on a floor by himself, for his own protection, they said," Gossom said. Because of this, Franklin didn't complete his degree at Auburn, though he would later achieve his master's degree from the University of Denver and become a college administrator. By the time Gossom arrived a few years later, he experienced some of that same isolation, even as part of a team.

African Americans weren't allowed in many of the student hangouts, forcing Gossom and his friends to drive to Tuskegee for a social life.

"We knew where not to go and which professors not to take," Gossom said. "At the time, there wasn't anybody to talk to [about the experience]."

On the football field, Owens and Gossom earned respect.

One of James Owens's most memorable plays was a kickoff return for a touchdown against Florida in 1970, a game Auburn won 63–14. Owens became a minister, and his nephew, LaDarius Owens, would join Auburn's team in 2009.

Gossom recalls playing in the legendary "Punt, 'Bama, Punt" game on December 2, 1972, when powerhouse coaches Bear Bryant and Shug Jordan squared off at Legion Field in Birmingham. With only ten minutes left in the game, Alabama appeared to have the game won. The score was 16–0. Then Auburn scored a field goal, bringing the score to 16–3.

When Auburn players managed to block two Alabama punts and run them back for touchdowns, the game ended with Auburn on top, 17–16. The game was later ranked number fifty-five on ESPN's list of one hundred defining moments of college football. ESPN also ranked the game as the eighth most painful finish in college history.

While Gossom has said he felt isolated at Auburn, he has since admitted that he didn't always make the transition easy. In 1974, he joined thirteen other black athletes—three other football players, six basketball players and four on the track team—in a protest of a Shug Jordan policy that his football players were prohibited from wearing facial hair.

The Associated Press reported on February 9, 1974, that the protest had ended, and Jordan was calling for the termination of his athletes' scholarships. He named Gossom, Mitzi Jackson and Sullivan Walker as players with whom he felt he had a "close" relationship who had resisted his policy. The other athletes left as a show of unison for the football players.

At the time, Gossom had a long Afro, as was the style then, and some facial hair. The protest ended peacefully, and Gossom said he has always had the greatest respect for Coach Jordan. He has said that the three most powerful men in Alabama at the time were Governor George Wallace, Bear Bryant and Shug Jordan.

After graduating from Auburn, Gossom was drafted by the New England Patriots but didn't sign. Instead, he went to play in the newly formed World Football League, and when it folded, he played briefly with the Buffalo Bills.

He went on to receive his master's degree and worked for a time in journalism, writing a column for the *Birmingham News*. Then he landed a role on the television series *In the Heat of the Night*, one of the highest-ranked shows in the country at the time.

His acting credits include guest spots on many top shows, including *Cold Case*, *Without a Trace*, *ER* and *Boston Legal*, and appearances in movies such as *Miss Evers' Boys*, *Fight Club* and *The Chamber*.

Gossom married his wife, Joyce, in 1997. After filming *Miss Evers' Boys*, Gossom was attending an event in Los Angeles when he was approached

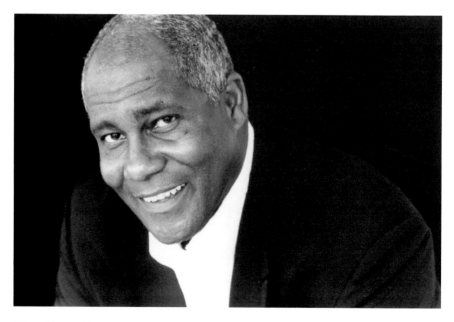

Thom Gossom Jr. went on to be a successful character actor, starring in movies such as *Miss Evers' Boys* and *Fight Club* and numerous television shows. *Courtesy of Best Gurl Entertainment.*

by an agent. He and Joyce agreed that they would move to Hollywood, but Gossom flew back and forth for a time until their son, Dixson, graduated from high school. Gossom also runs Best Gurl Entertainment.

In 2002, Gossom was invited to a reunion of the Auburn team. He didn't want to go. After talking with Joyce, he decided to go and see what happened. The visit was cathartic.

"My teammates and I have come a long way," Gossom said. The emotional reunion led Gossom to write his memoir, *Walk On*, published in 2008.

Gossom said of those first black athletes: "We were the messengers chosen to walk through those doors. There was emotional pain to that."

Yet, there is pride as well. Gossom said he now carries his legacy with honor. He serves on the board of Auburn University's foundation and gives inspirational talks to students.

API Alums Reunite…In Prison

When recent Alabama Polytechnic Institute graduate Winston Garth arrived in Germany in the early 1940s, he ran into his college buddy Alvin Vogtle. The two men, who hadn't seen each other for a couple years, greeted each other enthusiastically, laughing at the coincidence.

The setting, however, couldn't have been less suitable for a reunion: the men met in 1943, at Stalag Luft III, a notorious prison camp where they were held during World War II.

Over the months Vogtle (pronounced *Vō-gul*) and Garth were imprisoned, the men would help keep up each other's spirits, but Vogtle had a decidedly different reaction to being a POW from the steadfast and reliable Garth.

Alvin repeatedly tried to escape to return quickly to his hometown love and future wife—leading many to claim he was one of the men on whom Steve McQueen's character was based in the film *The Great Escape*. When asked why he continued to put his life at risk with the escapes, Vogtle said that he needed to get home to Kathryn before she married someone else, said Alvin's daughter Anne-Moore Baldwin.

Winston, on the other hand, refused to risk being killed during an escape, but his reason also was love: he wanted to return home to Athens, Alabama, and his wife of one year, Marion.

Days at API

Though Alvin and Winston were the same age, Alvin was two years ahead of Winston at API, having started college at the age of fifteen.

Vogtle left Auburn in 1938 and went to the University of Alabama to study law. Winston, who was studying electrical engineering, was set to graduate in 1940.

While at Auburn, Vogtle worked on the business staff of the *Auburn Plainsman*, helping with circulation and ad sales. He also was sophomore class president and a member of Sigma Nu fraternity.

Garth had pledged Phi Delta Theta and was an officer in the Interfraternity Council. The friends would sometimes face each other on the intramural football field, as students from each class would compete.

The men attended the many dances held on campus, sponsored almost every weekend by a different fraternity or sorority.

"They lived large," said Winston's daughter, Nancy Garth Shotts.

It was a carefree time, and yet behind it all lay the threat of war.

POWs

Garth was born on March 28, 1918, to Ethel Mae Hightower and Winston Stuart Garth Sr. of Athens, Alabama. He attended the McCallie School, a private high school in Chattanooga, where he was an outstanding diver.

Alvin Ward Vogtle was born on October 21, 1918, to Ollie Irene Stringer and Alvin Ward Vogtle Sr. in Birmingham. At Ramsay High School, he skipped two grades. During the war, those Alabama roots earned him the nickname "Sammy from Alabamy."

As Garth was preparing to leave Auburn, hundreds of young men had already enlisted to help fight what many believed was an unavoidable war.

Garth entered U.S. Air Force officer training in 1941. While home in Athens on leave, he would meet Marion Hoover, who was in town from Kentucky visiting a friend of her father's. They fell in love and were married in 1942, with Winston dressed in his air force uniform. Winston received his wings on April 29, 1942, and was shipped overseas.

Exactly one year later, on April 29, 1943, Lieutenant Garth was flying as wingman to help protect flying ace Colonel David C. Schilling when his plane was shot down.

The men had been doing surveillance in the North Sea off the coast of Belgium. Belgian fisherman picked up Garth, who had landed in the sea, and turned him over to the Germans.

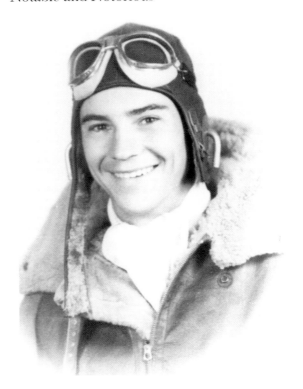

Winston Garth, a World War II pilot shot down and taken prisoner, refused to participate in escape attempts with his friend Alvin Vogtle because he wanted to get home to his wife in Athens, Alabama. *Courtesy of Jerry Barksdale.*

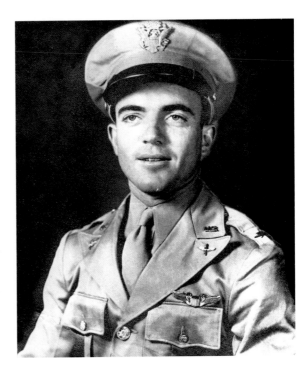

Alvin Vogtle, who graduated from Auburn in 1938, made five escape attempts before finally gaining freedom from Stalag Luft III during World War II. Some of his exploits are featured in the film *The Great Escape. Courtesy of Ann Moore Baldwin.*

Alvin joined the United States Army Air Force Reserve shortly after graduating from University of Alabama law school in 1941. He already had extensive flying experience, having learned to fly in the Civilian Pilot Training program.

Several months before Garth was shot down, Vogtle's Spitfire was forced down after shots were fired at his plane in North Africa. He was captured and transferred to Stalag Luft III.

The site, located southeast of Berlin, was chosen for the prison because Germans thought prisoners would not be able to dig tunnels. However, Stalag Luft III became the site of one of the war's most famous escapes, the one chronicled in the 1963 novel *The Great Escape*, written by former prisoner Paul Brickhill.

The character played by Steve McQueen in the film version of *The Great Escape* was based on traits and recollections from several POWs. McQueen visited Vogtle in Birmingham before filming began and asked him to share his experiences.

Alvin's first escape attempt from Stalag Luft III was replicated in the movie. Alvin was hiding in the back of a hay truck, which the guards checked for escapees by thrusting pitchforks into the hay. A pitchfork prong went through the leg of Alvin's fellow escapee, who was caught. Even though the forks did prick Alvin several times, he was deep enough in the hay to avoid detection, said his granddaughter Katie Kirtley.

Vogtle's five escape attempts are well documented. He finally succeeded in finding freedom on his sixth attempt in 1945, when he escaped and swam across the Rhine River to Switzerland. Garth would spend about two years in the camp. While there, the men were allowed to receive mail from their families.

"They could get care packages once a month, and they wanted coffee, cigarettes, good books and sugar," Shotts said. "Mail was censored, but they wanted news of ballgames and current events."

The POWs found a way to brew whiskey, which they would make for Christmas, and they made their own soap and built radios from parts they would find.

Vogtle made a compass to help him navigate during his escape.

"They were often cold, but they felt they were being treated fairly, according to the Geneva Convention," Shotts said. "My father never did want to eat Brussels sprouts again."

Marion had been notified that her husband's plane was shot down and he was declared missing in action. "For months, Mother didn't know if he was

dead or alive, but then word came through ham radio operators that he was a POW," Shotts said.

On May 8, 1945, the *Alabama Courier* newspaper in Athens ran news of Winston Garth on the same page with the banner headline "Unconditional Surrender Won by Allies over Germany." The small item with a photo stated: "A cable from a Red Cross worker said, 'I saw Winston today, he is well and alright, will be home soon.'"

His family would later learn that Garth had been liberated by General George Patton from the stalag on what he considers his lucky day, the same day he received his wings: April 29.

Following his escape in 1945, Vogtle came home to marry Kathryn Drennan, and they would raise Kathryn, Alvin and Anne-Moore. He would become president of the utility firm Southern Company, which would name a Georgia nuclear power plant in his honor.

Shotts recalls that her father shared with his children his love for Auburn and took the grandchildren to football games.

"Daddy always sang the alma mater with his hand over his heart, and he sang it with the words 'API' because that's what it was when he was there," she said.

Alvin's love of Auburn University and its football team remained strong as well. During the 1950s and 1960s, he didn't miss attending a game for eleven straight years.

"He dearly loved Auburn to the end," Anne-Moore said.

Garth and Vogtle remained close until Vogtle's death in April 1994. Garth died on October 7, 1996.

MISS ALLIE'S ORANGE-AND-BLUE SWEATER

As a young man, Emory Thomas Glenn rode into the tiny village of Auburn in what was then Macon County, Alabama. It was a picturesque and untainted land in the mid-1800s, perfect for farming and raising a family, both of which Glenn did.

He also would make a career in one of Auburn's other major offerings: education.

Glenn was born in Meriwether County, Georgia, on May 1, 1930. In 1852, he would marry Helen Elizabeth Ross Glenn, who was born in 1835, and they would have thirteen children, not all of whom survived to adulthood.

E.T. had come to Auburn with other family members, including his parents, the Reverend John Bowles (sometimes written "Boles") Glenn and

Moriah Allen Glenn, after a town founded by the family, nearby Glennville, was destroyed by Creeks in an 1836 uprising. The families eventually left their town and settled in Auburn.

After the Treaty of Cusseta was signed with the Creeks in 1832, the first white settlers arrived in Auburn in 1836 from Harris County, Georgia. The leader of these settlers, Judge John J. Harper, was determined to make the unspoiled land into a religious and academic center. Over the course of the next three years, Methodist and Baptist churches were raised and a school opened. After Auburn's incorporation in 1839, male and female academies were built. The opportunities for education drew wealthy planters from across the South.

Two decades after settlers first came to Auburn, the Alabama legislature chartered the East Alabama Male College in the center of town.

J.B. Glenn and E.T. Glenn discovered they had talents to offer the new school and, through one of E.T.'s children, would leave a legacy in a football tradition that lives on today.

On May 9, 1857, articles of incorporation were filed with the state for the new college. The Glenns were among sixty-six men listed on the document as "members of the board appointed under charter and elected since."

The document stated: "Be it enacted by the Senate and the House of Representatives of the state of Alabama in the General Assembly convened that a Male College by and the same is hereby established in the Town of Auburn in the County of Macon to be known as the East Alabama Male College."

It went on to outline the duties of officers such as the president, vice-president and treasurer. John Glenn was appointed the first president of the trustees, and E.T. was named the college's first treasurer.

E.T. would be treasurer until his death, with the exception of a period during and following the Civil War. During the war, he was listed on the muster roll of the Macon County Reserves on October 5, 1863.

E.T. returned as treasurer of Auburn's college in 1872, when it was called Agricultural and Mechanical College of Alabama. It would become Alabama Polytechnic Institute during his tenure.

A description of E.T. Glenn appeared in the 1897 *Glomerata*, the first yearbook published at the school: "In point of service he is the Nestor of the College officials, as his long and honorable career as treasurer covers thirty-five years—ten with the East Alabama Male College and twenty-five with the Agricultural and Mechanical College."

Helen Glenn died in 1901, and E.T. Glenn died on August 3, 1906. They are buried at Pine Hill Cemetery. Upon E.T.'s death, his daughter, Maria

Maria Allen Glenn, known to students as "Miss Allie," is credited with making Auburn's first letter sweater in the newly chosen colors, orange and blue. *Courtesy of Auburn University Libraries.*

Allen Glenn—written "Marie" in Auburn records but "Maria" in 1921's *History of Alabama and Dictionary of Alabama Biography* and on her headstone— took her father's place as treasurer at Auburn.

Maria Allen, who would later be known by students and faculty as "Miss Allie," was born on August 7, 1886. It was Miss Allie and Dr. George Petrie, who formed the football team in 1892, who are credited with deciding on the orange and blue worn by Auburn sports teams.

According to legend, before the college's first-ever football game to be played that fall against Georgia, a reporter for the *Atlanta Constitution* asked which colors Auburn's team would be wearing. Petrie said orange and blue, which were the colors of his alma mater, the University of Virginia.

Another legend states that Miss Allie had already put the idea in the minds of Petrie and the staff. The previous winter, she was knitting a sweater of navy blue. Knowing Petrie's love for Virginia, she decided to sew a prototype fan sweater or a varsity letterman's sweater, the type of which had come into use in 1875 at Harvard. She added orange lettering to the sweater.

Miss Allie later showed the sweater to a committee, and the colors were accepted. Several other colleges use the orange-and-blue combination—including the University of Florida and Boise State University—but the hues vary. Auburn uniforms are a dark blue rather than the royal blue worn by Florida.

Reportedly grateful for Miss Allie's sweater contribution, the football team asked her to be its sponsor for the first game. During remarks at her retirement in the 1940s, she said this was her highest honor while at Auburn.

Miss Allie died on February 12, 1953, and is buried at Pine Hill Cemetery along with her parents. Her stone is etched with the quote: "To live in hearts we leave behind is not to die."

Glenn Hall, a women's dorm built in 1952, was named in Miss Allie's honor. The City of Auburn would name Glenn Avenue, one of its major thoroughfares, after the Glenn family, who contributed so much to the college.

LEGENDS FROM PINE HILL CEMETERY

Little Charlie Miles, the "Lizard Boy"

In the 1930s in Mississippi, watermelon was a treat for many children, but to the Miles children, the sweet, juicy fruits had become a nuisance.

Dr. Lee Ellis Miles, father of Lallah, Charlie, Robert and Mary, was a plant pathologist who was trying to create a watermelon with a rind thick enough to allow it to be transported across the country for sale, a feat that previously had been impossible.

The children were the "taste testers," letting their father know which of his creations tasted sweetest. When they'd had as many as they could eat, the children were allowed to sell the fruit in a roadside stand to earn money to buy bicycles. Eventually, Dr. Miles succeeded, and the "Miles Melon" was created.

On other days, the children would follow their ingenious father into the forests or the fields, where he would search for rare tree diseases or determine a way to grow colored cotton.

Dr. Miles, who had earned an undergraduate degree in Illinois, served as a machine gunner in the Indiana National Guard during World War I before coming home to earn his PhD and work as an assistant professor in Illinois. He would eventually become a fellow of the American Association for the Advancement of Science.

In 1922, Miles went to the Alabama Polytechnic Institute in Auburn as a plant pathology professor. While there, he found an intellectual wife to share his unusual life—Eunice Rebecca Miles, who was raised in Auburn and graduated with honors from API in 1917 at the age of eighteen.

In 1928, the couple would move with young Lallah (pronounced *la la*) to Mississippi, where Dr. Miles worked at the Mississippi Experiment Station. There, the other children were born.

Within a few years, tragedy would strike the family.

Robert Lee Miles, a baby boy born on October 3, 1934, died within hours from a heart defect. In 1937, eight-year-old Charlie died from an allergic reaction to an insect bite.

Rebecca brought the boys home to Auburn to be buried at Pine Hill Cemetery.

For Charlie's marker, she chose a statue of a young boy holding a tray from which a small lizard looks up. Meg Perry, daughter of Lallah Miles Perry, said the marker was likely chosen to show the adventurous nature of a small boy, especially one who roamed nature's playground with a curious-minded father.

Charlie Miles, son of university plant pathologist Lee Ellis Miles, died when he was eight years old in Mississippi. *Courtesy of Meg Perry.*

Charlie's mother wanted to return his body to her hometown for burial, purchasing a statue of a boy looking at a lizard on a tray. It is the only marker of human form in Auburn's historic Pine Hill Cemetery. Nearby is the marker for his brother, Robert, who lived for only a few hours. *Photo by Rebecca Croomes.*

The marker is the only human form in the historic cemetery and the most often vandalized. The child's head has been missing for several years, as has the head of the lizard. Robert's marker—small and unadorned—is set next to Charlie's grave.

In 1941, another tragedy occurred when Lee Ellis Miles died at the age of fifty-one from a heart attack. Lallah was only fifteen years old.

Rebecca packed up the couple's daughters, Lallah and Mary, and returned to Auburn, where she lived out her life.

Lallah, who had been home schooled, enrolled at Auburn High School and graduated at the age of sixteen. She was in a rush to graduate because she had left the young man she loved back in Mississippi. She would marry James Lafayette "Dick" Perry, and while he fought in the South Pacific in World War II, she studied at API, graduating at the age of eighteen like her mother.

She had shown an early talent for art, starting to draw at age thirteen, and put her API art degree to good use when she started her life in Mississippi with her husband following the war. The Perrys had four children: Elizabeth "Pippa," Margaret "Meg," Pete and Richard.

Lallah would make an impact on the art world as a renowned painter and teacher. Her works were exhibited from New York to New Orleans and have hung in the National Watercolor Exhibition at the Smithsonian and in the American Embassy in Rabat, Morocco. She was the first director of the Mississippi Art Colony. In 2008, just months before her death, Lallah Miles Perry received the Mississippi Governor's Award for Artistic Excellence.

Her daughter, Meg, hopes to honor her mother's wishes and restore little Charlie's marker in Pine Hill Cemetery.

Uncle Billy Mitchell Buried in His Feather Bed

William Mitchell was known around Auburn as an easygoing man. Everyone called the prosperous farmer "Uncle Billy." He also was accustomed to getting his way, even in death. His unusual burial request would etch Uncle Billy's place in Auburn's history.

Mitchell was born on May 17, 1787, to John Mitchell and Sarah Thweatt Mitchell in Hancock County, Georgia. John, who was born in Virginia, had been a wealthy landowner and a lieutenant in the Revolutionary War. William was the fifth of ten children. His siblings were Thomas, John, James, Martha Goodwyn, Augustus Cadwell, Uriah George, Elizabeth, Henry Goodwin and Julius Caesar Bonaparte.

On November 22, 1808, Mitchell married Martha Hill in Oglethorpe County, Georgia. The couple would move to Montgomery County, Alabama, sometime in the 1830s and eventually to Auburn, which was then in Macon County.

Billy died on April 2, 1856, and Martha in 1861. A historical marker at Billy's grave site in Pine Hill Cemetery reads:

> *Mitchell believed a man should be comfortable and made specific arrangements for his eternal rest. His is a brick crypt above ground, not a typical grave at Pine Hill, but where he now eternally sleeps in his feather bed, his shoes tucked below.*

No one is sure why Uncle Billy made the odd request, but it remains one of the most unusual grave sites in Alabama. Uncle Billy and Martha had seven children—Mary J., Jeanette, Antoinette, Jourdan, William, Juliet and

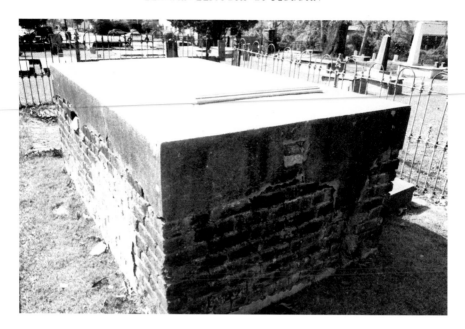

One of Auburn's wealthy planters, William "Uncle Billy" Mitchell, asked to be buried in his feather bed with his shoes tucked beneath. The unusual grave site is at Pine Hill Cemetery in Auburn. *Photo by Rebecca Croomes.*

a son named for Mitchell's brother, Julius Caesar Bonaparte Mitchell, who was called Julius.

It was Julius who would become perhaps the most prominent of the Mitchell family. Born in 1819, Julius was about twenty years old when he married Jane Murdock, daughter of close family friends, in the late 1840s. They had a son who died before his first birthday. Within months, Jane, too, would die. Julius married Jane's sister, Rebecca, in 1846.

By the time talk of secession began, Julius's plantation and other interests, including stock in railroads, had made him wealthy. His position afforded him the opportunity to attend the Democratic Convention in South Carolina in the company of his friend William Lowndes Yancey, a state legislator. He and Yancey gave speeches supporting secession in the days leading up to Lincoln's election.

Julius used part of his fortune to outfit the Thirty-fourth Alabama Infantry Regiment, where he served as colonel. Letters from soldiers in his unit confirm that he was generous in using his funds to keep them fed and clothed. After the war, Julius struggled financially and died in 1869. He and Rebecca, who died in 1881, are buried in a family cemetery at Bright Spot in Mount Meigs.

Murder, Mayhem
and Mystery

THE KILLING THAT HAUNTED A CHAMPION

In the fall of 1957, Bobby Hoppe returned to the plains of Auburn from his home in Chattanooga, Tennessee, ready to help the football team continue its rise under the leadership of Coach Shug Jordan.

When he took the field, the versatile halfback and blocking back showed he was as devastating as ever, making the plays that had earned him the nicknames "Chattanooga Choo Choo" and "Hippity Hoppe." So determined was he to help his team to a victorious season that Bobby played the first two games—against Tennessee and Chattanooga—with three dislocated ribs, enduring excruciating pain without telling teammates or Coach Jordan.

With Hoppe playing defensive back, Auburn would win the national championship that year, ending at number one in the polls after an undefeated season. No one realized that Hoppe (pronounced *Hopp-ee*) was carrying a dark secret and a guilt that would plague him for thirty-one years, until the day he admitted in a Tennessee courtroom that he was the man who'd killed moonshine runner Don Hudson in the summer of 1957.

Bobby claimed self-defense, and the trial ended in a hung jury. According to Bobby's wife, Sherry, who wrote a book about the case called *A Matter of Conscience: Redemption of a Hometown Hero, Bobby Hoppe*, the incident colored the remaining fifty-one years of Bobby's life.

Death on a Summer Night

July 19 had been a typical hot, sticky day in middle Tennessee.

Bobby Hoppe was home in Chattanooga from Auburn, where he planned to start his senior year in the fall. Everyone in town knew Bobby, the star of Chattanooga Central High.

Bobby, who was twenty-two that summer, was a clean-cut, good-looking young man with a bright future, everyone said. He'd likely go pro. The girls adored him, and the men respected his athletic prowess.

Don Hudson, twenty-four, was equally well known. He had a reputation as a bootlegger with a wild and, some said, violent side. He liked the excitement of running illegal liquor and was known to police, who had arrested him several times.

On July 19, Don was riding around town in his 1948 DeSoto when he was approached by police officers. Hudson complained bitterly that officers were harassing him because they had arrested him a few days earlier for transporting illegal liquor.

He then stopped at a store to buy a can of beer and rode off into the night. When Hudson was next seen, he was sitting in his car, which had run off the road and crashed into a utility pole. He had been shot in the side of the head with a .410-guage shotgun and would soon die at the local hospital.

Bobby knew Don's reputation well. Don and Bobby's older sister, Joan, had dated for five years and had recently broken up. Bobby heard that Don had beaten his sister. Don also had been charged in an earlier kidnapping and beating of a local man, but the case was dismissed. It was rumored that Hudson always carried a gun. Other rumors, which Bobby repeated when he finally came to trial, included the story that Hudson had attacked a man with a tire iron because the man had dated Joan. In another incident, Hudson reportedly saw Joan in a car talking with another man, and Hudson reached through the window and punched the man in the face.

Bobby, a large, strapping young man, felt he had reason to fear Hudson. When the men met on a dark road that night in 1957, one would die and the other would never be the same.

Gridiron Star

As Bobby Hoppe's senior year in high school ended, he was named the first high school All-American ever to come from Chattanooga. His stellar high school career made him one of the most highly recruited football players

of the day. Nineteen colleges sought Bobby, including Auburn, Alabama, Clemson, Georgia, Tennessee, Florida and Mississippi.

Many in Chattanooga were disappointed that he didn't choose a Tennessee college. Instead, Bobby chose Auburn and Shug Jordan.

Sherry Hoppe would later write that it was Auburn's homey atmosphere that swayed Bobby's decision. She said that unlike today when everyone wears jeans, people wore jeans at the time because they couldn't afford better clothes.

Bobby was quoted in the *Chattanooga News-Free Press* in 1974:

> *I had visited a lot of schools before I went down to Auburn. I didn't care for what I found—stuffed shirts and snobbish attitudes. Then I went to Auburn. Here I was, a kid with no money and dressed in blue jeans. I couldn't believe it—the kids were in jeans and they were friendly.*

Tennessee's loss was Auburn's gain. Hoppe would finish his career at Auburn ranked fourth on the all-time rushing list.

Bobby Hoppe was a halfback on API's 1957 national championship team. The summer before that season, Hoppe shot a bootlegger while home in Chattanooga but was not charged until three decades later. *Courtesy of Sherry Hoppe.*

When researching her book, Sherry came across a sports writer's account of the time two of Auburn's most famous athletes squared off: "[Paul] Reeder reminded folks Fob James, one of Auburn's greatest football players, had attended a private prep school in Hoppe's hometown. Once, during a 100-yard dash featuring both men, Hoppe won. 'James was extraordinarily fast but Hoppe was faster.'"

James would later become Alabama's governor. Hoppe would go on to play pro ball for the San Francisco 49ers and Washington Redskins before an injury ended his career. He would forever admire Shug Jordan, who brought Bobby back to Auburn as an assistant coach when his pro career ended so Bobby could complete his degree.

In a letter to the coach upon Shug's retirement, Bobby wrote:

> *Coach, I want to say that I know your entire being aches when Auburn loses. But, when the record books are opened in the end, they won't tell how many football games you won or how many bowl games Auburn was in. Rather, it will show how you helped your fellow man. Especially, it will show you helped many an Auburn football player to have a decent chance at life.*

Sherry, who would have a long and respected career as a college administrator in Tennessee, said she didn't realize her husband's status as a college football star until years after they married, when he was coaching at a Tennessee college and an announcer introduced him as a former All-American.

"I was astounded," Sherry said. "He had never told me how good he was. Even so, he wore his 1957 Auburn National Championship ring with pride and treasured his days at Auburn." Although she did not meet her husband until years after his football career, she said she knows that returning to Auburn and focusing on football in the fall of 1957 was "his salvation after he killed Don Hudson in self-defense."

> *He later told me how haunted he had been by taking another man's life, and I think throwing himself into helping his team win the national championship diverted his thoughts—at least wile he was on the field. Unfortunately, off the field, his conscience tortured him, as it did for thirty-one years between the incident and his indictment, and many times left him moody and depressed.*

The Truth Comes Out

It was after midnight, and the calendar had clicked over to July 20, 1957, when Bobby Hoppe and Don Hudson spotted each other on a dark road as Bobby headed home from a date.

Bobby would later testify that Hudson's DeSoto came up behind his Ford, its headlights off. Bobby said Hudson's car then pulled alongside Bobby's, and Hudson pointed a pistol at him. Without hesitating, Bobby grabbed the shotgun he had in his car and fired into the other car. Not knowing what damage—if any—he had inflicted, Bobby fled the scene. Although his name came up as a suspect in the shooting over the next decades, Bobby was not charged until 1988, when police reopened the case at the request of Hudson's mother, Georgia.

Bobby's trial began in June 1988. He was defended by famed attorney Bobby Lee Cook.

In more than seven hours of testimony, Bobby described the night he shot Don Hudson, emphasizing that he thought Don was about to shoot him and he acted in self-defense.

Prosecutors said no gun was found in Hudson's car.

The jury was unable to reach a unanimous decision, and the trial ended in a hung jury. Tennessee prosecutors initially said they would retry Bobby but soon decided that another trial would likely end in a similar way.

Sherry Hoppe said that although the trial was difficult and embarrassing for Bobby, it also was cathartic. Though he seemed more at ease after the trial, Bobby was, at times, still haunted by his action. When the 1957 football team held a reunion in 2007, Bobby told Sherry he could not face his former teammates. The Hoppes did not attend.

In 2008, Sherry Hoppe left her husband at their Chattanooga home to pick up some flowers for the yard. When she returned, she found her husband on the floor dead of a heart attack.

Writing the story of his anguish, she said, helped her cope. She had begun writing before his death and had received his consent on the project. She wrote: "Scarred by one life event, I don't think he ever realized what a profoundly good man he was. I'm thankful many others did."

THE UNSOLVED MURDER OF JETHRO WALKER

In the late 1840s, a new form of transportation was taking over the South. People tired of trying to drive carriages through muddy roadways had new technology on the horizon: plank roads. These roads were made by laying

planks across perpendicular boards, similar to rail ties. In this way, carriages could ride above the mud and make better time between towns.

In Auburn, Jethro Walker, the well-known owner of a large plantation, was a pioneer in the industry. While the first plank road in this country was reportedly built in north Syracuse, New York, southerners joined the boom and planned to revolutionize the industry.

In 1850, Walker and colleagues—James L. Butney, R.C. Holefield, George B. Nichols, Littleton Winn, Job Ross, Thomas J. Bedell and Micajah Bedell—sent a request to the state legislature to incorporate the Auburn and Tallapoosa Plank Road Company. Walker, a prominent citizen who owned a sawmill near Old Armstrong United Methodist Church in Notasulga, would have been an asset to such collaboration. The request was approved on February 13 with the stipulation that "the capital stock of said company shall not exceed the sum of seventy-five thousand dollars" and that it would be organized like the "Tuskaloosa" plank road company, eventually "touching to road herein proposed to be constructed."

The act also provided "that said road shall be commenced within three years and completed within ten years from the passage of this act." But within a matter of years, most of the plank road companies to be incorporated would fail because the technology did not live up to its promise.

Jethro Walker, who owned sixty slaves on his plantation, had other endeavors to fall back on. Walker also was an attorney and was prolific at marrying.

Born in Putnam County, Georgia, on February 18, 1808, Walker would eventually bring his family to the growing city of Auburn. He married Matilda Zachry on February 12, 1829, when she was about sixteen years old.

She and Jethro had five children: Josephine Louise, James, John, Fanny and Sohprinia. Matilda died on January 20, 1841, in Auburn and was buried at Pine Hill Cemetery.

Jethro then married Mary Elizabeth Mims on December 22, 1846, in Auburn. The twenty-three-year-old Mary Elizabeth was the daughter of one of Auburn's first town commissioners, Henry Mims, and his wife, Sarah. Jethro and Mary Elizabeth had one child, Mims Walker. Mary Elizabeth died in childbirth on February 21, 1846, and Mims was sent to live with her family in Uniontown, Alabama.

Jethro then married Martha Crittendon Terrell, who had a son from a previous marriage. She and Jethro had two children together: George Esterbert Walker and Vallie Walker. Not to be outdone by his father, George would marry four times and have seventeen children.

Jethro Walker was a successful businessman; he was devout and had a large extended family. What kind of father he was remains a mystery, but he had a contentious relationship with at least one son.

On the evening of March 14, 1858, Jethro Walker was sitting in his parlor reading the Bible when a bullet came through the window and struck him in the forehead. The murder was never solved, but one of Jethro's sons left immediately for Cuba and never returned. One family history said the son who fled the country was John.

Martha Walker buried Jethro beside the grave of his first wives at Pine Hill Cemetery.

According to legend, Matilda and Mary Elizabeth were buried in a single grave, one on top of the other, at Jethro's request. Martha, who would live to be one hundred and died in 1923, paid for the grave markers for Jethro and the three wives.

This large monument marks the grave of Jethro Walker, who was shot while sitting in his Auburn home in 1858. The murderer, thought to have been his son, was never caught. Walker's three wives are buried near him. *Photo by Rebecca Croomes.*

THE HAUNTING OF THE UNIVERSITY CHAPEL

In the summer of 1864, the charming village of Auburn could be a frightening place. A walk along the dirt street between downtown and the small campus of the East Alabama Male College was a tour of pain and death.

Old Main, the large building where the college's cadets had studied, was now filled to overflowing with soldiers who were dying and many who likely wished they would. Across the road that is now College Street, the Presbyterian church was also used as a hospital for Confederate soldiers, mostly those from General Hood's Texas Brigade.

The grassy lawn where cadets once drilled was now storage for bodies or, at times, body parts. It's not surprising, then, that some residents think restless spirits inhabit the area today.

Specifically, legend says, the spirit of a soldier named Sydney Grimmlett haunts the former Presbyterian church at the corner of College and Thach Streets, now the nondenominational University Chapel.

The 1851 chapel is the oldest building in Auburn still on its original site. According to the Auburn Heritage Association, it was constructed from

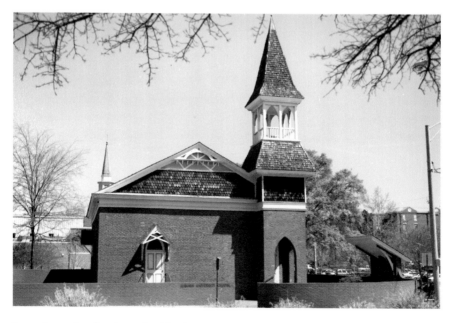

Legend says that the ghost of a Civil War soldier haunts the University Chapel, which was used as a hospital during the war. *Photo by Rebecca Croomes.*

bricks made by the slaves of its first pastor, Edwin Reese, on land donated by Judge John J. Harper, Auburn's founder. When a series of fires devastated downtown Auburn in the 1860s and 1870s, the chapel was spared.

Over the years, it has seen numerous owners and many uses.

The legend of Sydney's ghost began sometime after 1927, when the building was first used as a theater by the Auburn Players, a university acting troupe. Students reported hearing someone whistle when no one was there and the tapping of a foot from above. Sometimes, props would move seemingly by themselves.

Sydney is said to have arrived in this country from England in 1850 and took up arms for the Confederates when war broke out. Some say he was with the Sixth Virginia Cavalry; others claim he was with a Texas regiment. About one thing legends agree: Sydney was shot in the leg in a skirmish near Auburn. He was brought to the nearest hospital, the chapel, where his leg was amputated. Gangrene resulted, and the soldier died. With no family in the States, Sydney was buried at nearby Pine Hill Cemetery. No grave marked with his name exists today.

Some say Sydney's spirit followed the Auburn Players when they moved to bigger quarters in Telfair Peet Theater in the early 1970s. Others wonder if Sydney stayed behind.

On Halloween 2008, a group of five investigators from the Alabama Paranormal Research team stayed overnight in the chapel in an effort to determine if Sydney, or any other spirits, was haunting the site. They brought voice recorders and other devices to monitor the electromagnetic fields for the presence of spirits. According to a story in the *Opelika-Auburn News*, not much occurred—until late in the night.

"The power reading increased in the bathroom and there was an eerie feeling. Hand-held radios buzzed unexpectedly and, at the end of the night, the water was found dripping from a faucet despite being off before the investigation began," the story reported.

While the experiment ended with inconclusive findings, there are those who still believe in Sydney. When reports of the haunting began, beloved Alabama author Kathryn Tucker Windham wrote of the disturbances in her book *13 Alabama Ghosts and Jeffrey*.

At the Telfair, located at Samford Avenue and Duncan Drive, students leave candy to lure the spirit from hiding.

Why was Sydney quiet until the Players arrived? No one knows.

After the war, the Greek Revival–style building was used by Presbyterians and Episcopalians for a few years. In 1887, when the college's building, Old

Main, burned to the ground, the building was used for classrooms until Samford Hall was completed in 1888.

It also served as a social center for the USO and was for a time used as both the YMCA and YWCA. Students called it the "Y-Hut." At one point, it was made over in the Gothic style. It was listed on the National Register of Historic Places in 1973 and underwent a major renovation for its use during the country's 1976 bicentennial activities. At this time, it became the Auburn University Chapel.

Handmade trusses and slotted-and-pegged joists discovered during renovations are now showcased. The doors and steeple are replicas of the original Greek Revival building. Today, the chapel is used for a variety of university functions.

THE SLAYING OF SHERIFF BUCK JONES

When Margaret Linch was a little girl growing up in the 1920s, she would ride in the patrol car with her grandfather, Sheriff William Samuel "Buck" Jones. Grandfather Jones, who once owned Auburn Hardware on Magnolia

Lee County sheriff Samuel "Buck" Jones was shot to death when he went to arrest a murder suspect on June 29, 1932. *Courtesy of Margaret Linch.*

Street in downtown Auburn, had been encouraged by friends to run for sheriff of Lee County in the late 1920s or early 1930s.

Buck and his wife, Willie, and their daughters, Lois, Effie, Ursul and Nell, were well known and respected around Auburn. Buck was a charming and distinguished-looking man, not big in stature but big hearted. He easily won the election.

Lee County was a small place then. With its towns of Auburn and Opelika sparsely populated and farms dotting the countryside, few emergencies required Buck's response.

That changed on a summer day in 1932, when the sixty-year-old Buck found himself handling a murder investigation. A local man, Charles Green Miller, had taken an axe and gone on a rampage. He reportedly demolished the contents of his home with the axe before taking a razor and slitting his wife's throat. Miller then took a shotgun and went to the home of his brother-in-law, Taylor Matthews, and killed him, as well. His sister-in-law was seriously wounded but survived.

Early on the morning of Wednesday, June 29, Buck received a call telling him that Miller could be found back at the Millers' Opelika house. According to Jay Jones, sheriff of Lee County in 2011, Buck quickly deputized a local shopkeeper and hurried to the house.

This call would have been too dangerous for little Margaret, who was twelve years old at the time. In 2011, Margaret Linch Melson recalled that her grandfather told his family not to worry. "He said, 'I know this fellow. He's a good fellow. He won't give me any trouble.'"

Once at the Miller house, the sheriff approached the front door, sending his deputy to the back. Just as Buck opened the screen door to enter the home, he was blown back by a shotgun blast to the chest. Miller had fired once before Buck could enter, killing the sheriff.

Margaret had always heard that Miller was filled with regret. "'Oh, Mr. Buck. I didn't know it was you,' he said. He was very repentant."

Miller fled, running into the woods. A posse was quickly formed to find the man who had killed the county's beloved sheriff, the first law officer killed in Lee County in the line of duty.

When Miller was found, he was gunned down. According to some reports, he was shot more than fifty times. Miller's body was dragged to the courthouse lawn and left. None of the posse was ever charged in Miller's death.

The day after the shooting, Sheriff Buck Jones was buried at Rosemere Cemetery in Opelika.

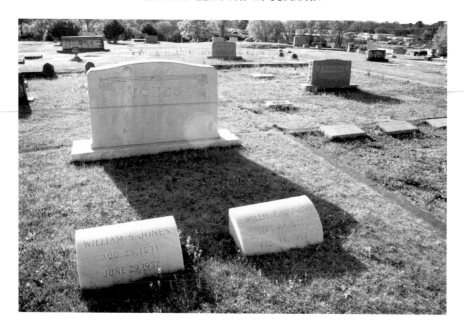

Buck Jones is buried at Rosemere Cemetery in Opelika. *Photo by Rebecca Croomes.*

In 2006, upon completion of a new Lee County administration building, Jay Jones, no relation to Buck, asked county commissioners to name it in honor of the county's only fallen officer. The W.S. Jones building was dedicated that year, with Margaret and her daughter, Sally Melson Phillips, in attendance. It had been seventy-four years since the slaying had shocked the county.

"We were just delighted that it was done," Sally says of the honor.

Jay Jones also ensured that Buck was listed on the fallen officers' Wall of Honor in Washington, D.C.

UNUSUAL DEVOTION BETWEEN SLAVE AND "YOUNG MARSTER"

More than 150 years ago, two young friends—who could never be divided by differences in race and class—were separated by a tragic death.

Jeff Wynn, whose parents and grandparents were quite prominent in Auburn, had a steadfast friend in Amos, the son of a slave who worked the Wynns' land. But on a hot July day in 1859, Jeff was killed in a hunting accident. Some say Amos was there and saw his friend and "young marster" die.

Jeff had been with his cousin, John Jackson "Jack" Harper, when Jack's gun went off.

Mary Reece Frazer recorded her memory of the incident, which was published in the 1945 edition of the *Alabama Historical Quarterly*:

> *Jeff Wynn and his cousin, Jack Harper (who, as you remember, was the son of Tom and Lizzie Harper) one morning went out hunting and by some means or other Jack's gun went off and Jeff was instantly killed. Jack brought the body into town crying at the top of his voice: "I have killed my friend. I killed my friend." Poor Jack came near to losing his mind. He felt that he could not live here after this terrible accident, so he left Auburn and went out to Mississippi. I do not think he ever returned.*

Jack never returned from Mississippi to live in Auburn. He soon would go to fight in the Civil War, marry and have a child of his own, only to have his own life cut short by an epidemic.

Jack Harper was born on June 15, 1838, in Auburn to Thomas H. and Elizabeth Taylor Harper. Tom was the son of John J. Harper, who had been a probate judge in Georgia before bringing his wife, Sarah Frances Ogletree, and their children to Auburn after the land was opened to white settlers in 1834. Judge Harper, whose father was a Revolutionary War militiaman, is credited with founding Auburn. When searching for a name for the town, his son's fiancée, known as Lizzie, mentioned to him that the unsettled land reminded her of the poem "The Deserted Village," by Oliver Goldsmith, which included the line "Auburn, sweet Auburn, loveliest village of the plain."

Lizzie had provided the perfect name for the new town.

Tom, who was born on November 13, 1815, in Wilkes County, Georgia, married Lizzie in 1837. About that time, Tom's sister, Amanda Frances Harper, would marry Littleton Wynn. Their son, Jeff, who was likely born in the 1840s, was Jack's first cousin.

Following Jeff's death, Jack left in despair, settling in Claiborne County, Mississippi, where he would meet his future wife, Olive Branch Powers. Olive Branch was born in 1835 to Henry and Laura Hedrick Powers.

When civil war broke out, Jack joined Van Dorn's Guard, where he was listed in records as a first lieutenant in 1862. Perhaps he wanted to redeem himself after his cousin's terrible death.

On October 30, 1878, Jack died in Mississippi during the yellow fever epidemic that was sweeping the South. Olive had succumbed just two

months before, on August 21, 1878. They are buried at Harper Cemetery in Jones County, Mississippi.

Amos's Tale

Not many records of Amos's life survive, although one record of Auburn's Baptist Hill Cemetery states that he had a son, Elias Wynn.

What is known about Amos is that he had an abiding sense of loyalty to Jeff Wynn, his one-time playmate.

Mary Reece Frazer wrote in the *Historical Quarterly*, "I ask all of you to go to the cemetery some day and see a simple head and foot-stone erected to the memory of Jeff Wynn. This was put there by his faithful slave, Amos Wynn. He told me he tried for a long while to get Mr. Wynn's relative to mark his grave but did not succeed."

According to some accounts, the grave at Pine Hill Cemetery was left unmarked because the Wynns moved not long after Jeff's death. Jeff's father, Tom, died of tuberculosis in 1843, so it's possible that the widowed Lizzie moved back to Georgia and may not have had money to mark the grave.

The absence of a headstone on his friend's grave bothered Amos.

In her history, Frazer wrote:

> So after 60 years that old negro begged the money from strangers and friends and erected this little stone to his young "marster," as he always called him. This poor old negro went hungry and cold but never used a penny of that money for his necessities. He kept it in trust with Mr. Burton. For sixty years, or more, Amos kept that one sacred spot.

How many years it took Amos to raise the money for the headstone varies with the telling. Many say he was a well digger and also dug graves.

The stone he finally purchased now rests in Pine Hill Cemetery, marked:

Jeff Wynn
Died July 26, 1859
By Amos Wynn

It is unclear when Amos Wynn died, but he was buried in an unmarked grave at Baptist Hill Cemetery. The cemetery, at the intersection of East Thach Avenue and South Dean Road and named for the church perched on a nearby hill, is the burial site for many people born as slaves. Ebenezer

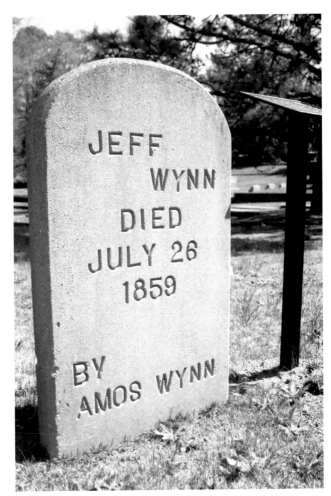

After young Jeff Wynn died violently, his grave was left unmarked, likely because his widowed mother moved from the area. Jeff's boyhood friend Amos Wynn, a slave, worked for many years to raise the money to erect this marker at Pine Hill Cemetery. *Photo by Rebecca Croomes.*

Baptist Church, established in 1865, was the first black church formed in Auburn after the Civil War. The cemetery was added to the Alabama Register of Historic Places in 1994.

As time passed, an anonymous person, who was bothered by the irony of the omission of a stone for Amos, purchased a marker that reads:

Amos Wynn
Born in slavery
At his own expense he had a marker placed on grave of his former master
Erected by a white friend 1947

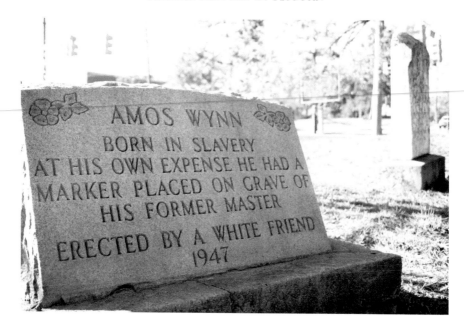

Following the death of Amos Wynn, a man in the community purchased a marker for his grave at Baptist Hill Cemetery, just as Amos had once done for Jeff. *Photo by Rebecca Croomes.*

According to one account, that friend was Dr. Charles Glenn. Mary Reece Frazer wrote, fittingly, "I never knew a more touching instance of a slave's devotion to the memory of his young master."

BIZARRE ACCIDENT LEADS TO ROOMMATE'S DEATH

In 1871, the East Alabama Male College at Auburn, a private Methodist academy that had been closed and its main building used as a hospital during the Civil War, was on the verge of becoming the state's agricultural and mechanical college. The academy had a rough start in 1856, when the governor vetoed its charter during a battle of the Methodists over placing a college in Greensboro or Auburn. Both towns eventually won. The Auburn charter was passed by a majority of the legislature to override the veto, according to the *History of Alabama and Dictionary of Alabama Biography*.

Anson West is quoted in the book:

> *Their discussion on the college question was fiery and exciteful, and engendered strife never allayed, and inaugurated division never arrested… they had conceived the idea of establishing, in their midst, a literary institution of high grade. In the projection of their commendable ambition they had aroused their latent forces, put under contribution their energies, and called into requisition their resources. The work, in its inception and design, in its outline and detail, in its execution and progress, was under intelligent guides and native agencies, and was not the outcome of day-dreams, wild reveries, and idle rhapsodies.*

Within fifteen years, the legislature was again in a heated debate about the fate of the educational institution. Federal aid was available for an agricultural and mechanical college, and some lawmakers wanted to use the existing East Alabama Male College.

Once the decision was made to change the Auburn school to the Agricultural and Mechanical College of Alabama, officials decided that those who graduated in the next academic year, 1872, would be the first to have diplomas bearing the A&M name.

It was in this atmosphere that two young roommates, whose names are lost to history, were part of a tragic incident at East Alabama Male College.

The young men would have been among the first to receive A&M diplomas, but it was not to be.

In January 1871, a doctor was summoned to the dorms, where he found a student lying near death on his bed. The physician had been called by the student's roommate, but it was too late. The young man died.

The cause of death was head trauma. It wasn't long before authorities learned from the roommate of the events leading up to the young man's death.

An account published in the *New York Times* stated that the story had initially been published in January in the *Atlanta Sun*.

Under the headline "Murder of a College Student by His Room-Mate," the reporter wrote, "A most sad occurrence took place at East Alabama Male College, situated at Auburn, Ala., one day last week. Two young men, aged about nineteen years each, were attending college, and were room-mates, and of course, the best of friends."

The roommates began tossing an apple around their small room, and as mothers always warn, someone got hurt.

The New York Times

Murder of a College Student by His Room-Mate.

From the Atlanta (Ga.) Sun, Jan. 13.

A most sad occurrence took place at the East Alabama Male College, situated at Auburn, Ala., one day last week. Two young men, aged about nineteen years each, were attending college, and were room-mates, and of course the best of friends. It seems that while in their room they began playing with an apple, by pitching it at each other, and at last one of them threw it rather hard, striking his friend in the face. This so enraged him for a moment that he seized a chair and struck the other over the head, felling him to the floor. When, fearing he

The *New York Times* published an article in 1871 about a bizarre incident that left a student at East Alabama Male College dead.

It seems that while in their room they began playing with an apple, by pitching it at each other, and at last one of them threw it rather hard, striking his friend in the face. This so enraged him for a moment that he seized a chair and struck the other over the head, felling him to the floor. When, fearing he had seriously hurt his room-mate, he picked him up, put him on the bed, and endeavoring to get him to speak. The wounded boy lay thus insensible for a day and a half, while the other one told no one about it, making some ordinary excuse when questioned for his absence.

Finally, someone became more curious about the boy's whereabouts, and his roommate finally admitted his friend had been injured.

The physicians were at once summoned, but too late. The fractured skull had rested upon the brain too long, and death ensued. He could have been

saved if assistance had been called in time. It is supposed the young man who gave the blow was not conscious of the serious damage he had done, and hoping his friend would soon be over it preferred to keep the affair quiet.

No mention is made of the surviving student's punishment, if any, but because the article referred to it as a murder, it is likely some charges were considered.

The incident showed that even this quiet, academic town of fewer than one thousand residents was not immune to tragedy.

Tiger Traditions

Bodda Getta—Wha?

One of Auburn University's most recognizable traditions has managed to remain steeped in mystery for decades. Perhaps the nonsensical nature of the familiar chant "Bodda Getta" lends itself to tales of more romantic origins.

An Internet search for "Bodda Getta" brings dozens of results, most of them asking, "What does it mean?" One blogger wrote in 2010, "I think it came from Pat Dye when he was talking about playing Alabama for the first time; something about the color of the sun and shakers maybe."

Hmm. Just for the record, no colors are mentioned in the cheer, with the exception of blue, which, as every Auburn fan knows, is only the color of the sun on days when Auburn wins a national championship title.

The words to the chant are:

> *Bodda getta, bodda getta, bodda getta, bah*
> *Rah rah rah*
> *Sis boom ba*
> *Weagle, weagle*
> *War damn eagle*
> *Kick 'em in the butt Big Blue…Hey!*

No one remembers the original spelling of the words—some say "bod" instead of "bah"; some write "wegl" instead of "weagle." The spelling above became "official" when it was printed on T-shirts licensed by Auburn

University and sold at local bookstores. Trey Johnston, a J&M owner, said he devised the spelling of the chant because he had no written record on which to base it.

Before all hope was lost of solving the great Bodda Getta mystery, a plausible version of the chant's origins surfaced.

The year was 1965. The Auburn University Marching Band—the only one in the SEC without a nickname because it's so good it doesn't need one—was welcoming its incoming freshmen members in the usual way. Each frosh was given a hat marked "RAT." Freshmen had long been nicknamed "rats" on many college campuses, and numerous colleges distributed rat caps, but at Auburn, RAT stands for "Rookie Auburn Tiger." At Georgia Tech, RAT means "Recruit at Tech."

The 1948 *Glomerata* stated that RAT caps were distributed to freshman by a "Rat Cap Committee" of the student executive cabinet, which provided the orange-and-blue RAT caps that were "the most familiar emblems of the Auburn Spirit."

In 1949, the *Glom* stated that the committee sold "more than the usual number of rat caps to male freshmen and it set a precedent by selling caps to many of the ratlets." The term "ratlet" referred to female freshmen. These days, RAT still stands for "Rookie Auburn Tiger," but it refers to a program for freshman band members to help smooth their transition to college.

Historically, when rats joined the Auburn Marching Band, they had another obligation in addition to wearing caps. They were required to make up a cheer for the band to chant during football games that fall.

This RAT cap was worn by Sherill Clontz, a member of the Auburn University band in the 1970s. *Courtesy of Sherill Clontz.*

This photograph from the 1967 *Glomerata* shows the Auburn Marching Band in 1966, around the time many believe the cheer "Bodda Getta" originated as a band chant. *Used with permission. Auburn University Libraries.*

John Penick, class of 1969, and Mike Watson, who was a band "rat" in 1965, remember that "Bodda Getta" was created by a group of "rats" about 1965.

"I recall that 'Body Getta' sort of developed as a chant, and it grew into a rhyming cheer with southern 'get 'er done' kind of language," Watson said, although he said he prefers to recall the band's great tradition rather than what he termed its "barnyard chants."

As Watson infers in his quote, several people recall thinking the chant had to do with "body," as in getting a body up to cheer, and that it may have been initially pronounced "Body Get A."

Watson also said the reference to "Big Blue" came during a time when blue was Auburn's dominant color.

"Those were the days when Auburn fans cherished our 'blue heritage.' Tommy Tuberville switched us to orange in the 2000s," he said.

Susan Nunnelly, who would go on to have a long career working for Auburn in the Student Recreational Activities Department and as faculty advisor to the cheerleaders, was a rat in 1966. She recalled saying "Bodda Getta" with fellow band mates. It really has no meaning, she said. It was merely a cheer to get the students roused for a game.

The chant may stem from a tradition in Auburn that goes back at least as far as 1897, when the school was Alabama Polytechnic Institute. Each class would have a "yell" to chant at functions or games, many including rhyming, nonsensical words.

In 1897, when the university's first edition of the *Glomerata* was published, it included two senior class yells. The first was:

> *Razzle, dazzle, sizzle, sazzle*
> *Sis—boom—ah!*
> *'97, '97*
> *Rah! Rah! Rah!*

Another was more racy for the time period and couldn't be published uncensored in the yearbook:

> *On our way to (blank) or heaven*
> *We are the class of '97*

The yells stayed consistent for the next few years. The class of 1898 would yell:

> *Sis—boom—ah!*
> *'98, '98*
> *Rah! Rah! Rah!*

> *Hullabaloo—baloo—baloo*
> *How d'ye do? How d'ye do?*
> *Senior!*

Forty-five years later, "Bodda Getta" has become part of Auburn's fabric. Many traditionalists don't like the cheer but admit that it has taken on a life of its own. As students began chanting along with the band in the 1960s, their love for the cheer grew.

David Evans, who was an Auburn freshman in 1973, recalls that the Auburn High School band members learned the chant in class in 1972 after a fellow band member wrote it on a scrap of paper at an Auburn game.

"When I was in college the next year, everybody was doing that cheer," Evans said. "I sat with a church group, and we'd say 'War darn Eagle' instead."

Over the course of several years, the cheerleaders made it an "official" Auburn cheer. Hopefuls are required to perform "Bodda Getta" when trying out for the cheerleading squad. At games, it is led by the "mic man," who announces the cheer to the crowd with: "Are you ready? Count off 1…2…3."

Many people say "Bodda Getta" is their favorite Auburn cheer. For many alumnus, teaching the cheer to their children marks the only time their tots are allowed to curse. YouTube is filled with videos of children repeating the chant in living rooms, bathtubs and McDonald's or fans chanting in held-over airplanes on the way to the 2010 national championship.

A fundraising barbecue event in Auburn has been named the Bodda Getta BBQ, and a book published by the *Opelika-Auburn News* to commemorate the 2010 national championship is called *Bodda Getta: Auburn's Remarkable Run.*

Probably because it has become so beloved, students at other universities make fun of the chant. A good response? Repeat the words to Ole Miss's "Hotty Toddy" or Alabama's "Rammer Jammer." Here are the words to "Hotty Toddy":

> *Are you ready?*
> *Hell, yeah! Damn right!*
> *Hotty Toddy, Gosh almighty*
> *Who the hell are we, Hey!*
> *Flim Flam, Bim Bam*
> *Ole Miss, by damn!*

Alabama's cheer ends with the lines:

> *Rammer Jammer, Yellowhammer,*
> *Give 'em hell, Alabama!*

So there you go. The competition can't take "Bodda Getta" away from Auburn fans, no matter how insecure their fans are about their own cheers. *Kick 'em in the butt, Big Blue! Hey!*

COLLEGE IS SERIOUS BUSINESS

Anyone who has ever seen the movie *Animal House* knows college is a place where reality is skewed by a newfound sense of freedom and independence that, sadly, does not always translate into responsible, adult behavior.

Campuses have long been places where boundaries are pushed, kegs are funneled and panties are raided.

While Auburn was a conservative and traditional campus in the 1950s and '60s, students weren't above a few pranks that may, at the time, have made parents and the faculty blush. From panty raids to "orienting" freshmen, the following are some wild and crazy incidents from days gone by.

Initiating Campus Rats

The first day at college was terrifying for students. Riding a train into town, freshmen at Auburn, referred to as rats, were met by upperclassmen welcoming them to campus. It was the "greeting" that came after dark that instilled fear in the bravest of rats.

In 1897's *Glomerata*, the first yearbook published by the college, junior class historian P.M. McIntyre recalled the first day at Alabama Polytechnic Institute:

What can I say of that first night in Auburn? What words of tongue or pen can do even scant justice to those terrible paddles, or painful paddlings—or cruel paddlers? With malice aforethought did those Seniors descend upon us. Some of us sought safety in flight, some in closets. But why go into the painful harrowing details? Suffice it to say that innumerable bottles of arnica salve were necessary before we thoroughly efface the painful evidences of that night of physical and mental torture.

Sophomore class historian H.D. Green wrote in the same yearbook:

In the days of our early "rathood," we probably did appear rather green, but every trace of that verdancy has disappeared and our intellectual geniuses now hold their own with any of the higher classes. In fear and trembling we sat in our rooms and listened to the rattle of the paddles on the fence, anxiously awaiting our turn. "It is divine to forgive" and we have forgiven but not forgotten, and we will use our best endeavors in the future to help the unsuspecting "Rat" in every way possible.

In the 1898 *Glomerata*, a freshman described the plight of the frosh:

Here he is taken in hand by some sympathetic cadet who safely steers him to a "ranch," where being duly installed, in fear and trembling he

waits for nightfall. It comes, and with it a whooping, howling mob of last year's freshmen with paddles, palings, sticks and straps. Soon the poor fellow devoutly wishes that his anatomy was all feet, and winged feet at that.

In 1922, school officials made the effort to quash the ritual of paddling freshmen. The 1922 *Glomerata* states:

We were also notified that hazing had been abolished and anyone caught hazing a new student would be sent home. Remembering what they had undergone the previous year, some members of the sophomore class undertook to acquaint the new students with the thrills of college life and as a result, our class lost about twelve men.

The Accidental Flashers

On October 10, 1952, the Associated Press published an article seen across the South about a slight problem at a female dorm. A story published in the *St. Petersburg Times* in Florida was headlined "Until Blinds Appeared, Gridders' Best 'Passing' Was by Gals Windows."

UNTIL BLINDS APPEARED

Gridders' Best 'Passing' Was By Gals' Windows

AUBURN, Ala.—ᴬᴾ—Football practice hasn't been all drudgery at Alabama Polytechnic Institute (Auburn) this Fall, it turned out yesterday, but the fun's over.

The one-way vision windows in the new girls' dormitories now have no-way vision. School authorities hastily covered them with Venetian blinds when they discovered the window panes had been put in backwards.

Coeds moved into the five new buildings last week. Two of them face the row of cabins where the football squad lives. The other three face the street.

The girls blithely bathed, dressed and washed their undies behind frosted glass bathroom windows.

They assumed that because they couldn't see out, no one could see in. But because of the trick glass, it was the same as

This cartoon accompanied an article in Florida's *St. Petersburg Times* on October 10, 1952, after an error left Auburn coeds exposed.

Here's the story behind the story. Five new buildings were constructed for women on the campus of Alabama Polytechnic Institute when they began classes that fall. Two of the dorms faced a row of cabins that provided housing for the football team

"The girls blithely bathed, dressed and washed their undies behind frosted glass bathroom windows," the AP story stated. "They assumed because they couldn't see out, no one could see in. But because of the trick glass, it was the same as if they went about their primping in an aquarium."

It seems specialty windows had been ordered to provide lighting and views to the dorms while ensuring privacy. One side was frosted so no one could see in. But the company placed handles on the wrong side of the windows, causing them to be installed backward. The girls couldn't see out, but everyone walking past the windows could see in.

"Student pedestrian traffic was thick on the sidewalks in front of the dormitories facing the street. Because the girls' quarters are all on the first floor, outsiders got an eye-level eyeful," the AP wrote.

The crowd that day included some of Ralph "Shug" Jordan's football players, who were supposed to be on their way to the showers after scrimmage.

A gallant student tipped off the women that they were giving a peep show and "broke up the fun," the article stated. API officials rushed to install blinds, and the incident was over but probably not forgotten.

A story in the *Lewiston Morning News* stated that the situation left coeds blushing "when they look at a goldfish bowl."

Undie-niably Fun

After World War II, male students on the GI Bill flooded onto Auburn's campus. As was the case on campuses across the country, they were joined by more female students than ever before.

This influx caused consternation among the puritanical adults of the day. Women, they felt, needed to be protected from young, hormonal men. Dorms were same-sex only, and women's dorms had chaperones. Women had earlier curfews, and men were not allowed in the female dorms after bedtime.

In response to these strict standards for women, men on many campuses began staging "panty raids." Large groups of men would enter dorms and sorority houses, taking with them pairs of female "naughties."

Katherine Cooper Cater, dean of women and social director from 1946 to 1980, wanted to ensure that her women knew how to handle themselves in

any situation, including panty raids. She printed a set of instructions called "Rules for Women in Case of Panty Raids."

The female students were told not to go to windows or encourage the raiders in any way. Instead, they should turn off lights and sit in the hallways, wearing raincoats or robes for modesty.

The law, though, felt that the women needed backup. In 1952, newspapers were publishing stories about panty raids across the country. The May 22, 1952 edition of the *Hartford Courant* was headlined: "Law Snaps at College Panty Raids: Souvenir Seekers Line Up in Parades Before Civil Judges." The same day, the *Sun* in Baltimore, Maryland, wrote, "U. of M. Gets into Panty-Raid Act: 1,000 Students, Defying Pleas, Barge Through Dormitories in Search for Lingerie."

An Associated Press story published the previous day in newspapers as far away as Vancouver told of the increasing incidents of panty raids.

"Pantie Raids Flare again on U.S. Varsity Campuses," a headline read in the *Vancouver Sun*.

Collegiate panty raiders hit again in many sections of the United States Tuesday night, but co-eds and police stymied most attempts to filch lacy souvenirs. There were some arrests and a few reports of damage. In general, however, the undi-snatchers seemed somewhat less boisterous than the thousands of youths from nearly a dozen schools that joined in the latest college craze Monday night.

The Associated Press stated that the fad had begun mere weeks before and blamed the trend on "sex, simplemindedness and just a means of blowing off steam before final examinations start."

Well, yeah. It's college.

The article added, "Police halted a potential raid at Alabama Polytechnic Institute when several students gathered. About 25 students rushed photographer Paul Robertson and reporter Bill Bates of the *Montgomery* [Alabama] *Advertiser*, destroyed films and told them to get out of town."

Pop star Toni Tennille, who was an eighteen-year-old coed at Auburn in 1958, recalls panty raids.

"I experienced guys standing outside the dorms and yelling for panties. We were so repressed," she said with a laugh.

Susan Nunnelly, a student in the 1960s, said that by the time she was at Auburn, women threw their underthings from dorm windows to the male students waiting below.

It was likely a 1957 panty raid that led to a championship win that changed the course of Auburn's history and the life of Lloyd Nix.

Several football players, including the starting quarterback, were expelled after being caught in a women's dorm that year. Nix, now a retired dentist living in Decatur, Alabama, said in 2011 that he does not recall whether the players were on a panty raid, but they were definitely in the dorms when they were not allowed to be.

"Coach Jordan sent them home and told me he was moving me back to starting quarterback," Nix said. "It's been one of the best things that ever happened to me—then and throughout my life."

Nix led the Tigers to a 6–0 win over Georgia to cinch the national championship that fall. He went on to hold the record for passing yards in 1957 and 1958 and led the Auburn Tigers as the team captain in 1958.

The star quarterback said the fad of panty raids led many young men down the wrong path, but he managed to "rescue" one. A man who was once assigned as an associate pastor at the Nixes' church in Decatur pulled Nix aside and said, "When you were at Auburn, you saved my life. There were some students headed into a girls' dormitory on a panty raid, and you turned me around and led me out and kept me out of trouble," Nix recalled with a laugh.

When Auburn won the national title again after the 2010 season, Nix was wanted for dozens of interviews, and he and his wife, Sandy, were special guests at the game and at numerous celebrations. "I've just been honored to be a part of the celebration," he said. "It's been an exciting year for Auburn football."

Nix received the Auburn Alumni Association Lifetime Achievement Award in 2008 for his service to the community and to Auburn. His named is etched in an Auburn sidewalk on the Tiger Trail.

The Right to Wear Hair

These days, students entering colleges are warned to beware of hazing—Greek or other club rituals designed to teach newest recruits their place on campus. Some of the rituals, especially those involving heavy drinking, have led to tragedy. But at the East Alabama Male College, and later the Alabama Polytechnic Institute, students were more likely to have their characters tested than their constitutions.

Beginning in the days when male students were issued uniforms, called cadets and required to perform military drills, older students shaved the heads of incoming freshmen.

A student shaves the hair of a freshman cadet at the Alabama Polytechnic Institute in 1929. *Courtesy of Auburn University Libraries.*

In June 1929, an article by the Associated Press reported that head shaving had been banned at Alabama Polytechnic Institute by president Dr. Bradford Knapp, who said the practice was an "encroachment upon the prerogatives of individuals and not in accord with the progressive spirit of the institution."

Oh, Yes, They Called It the Streak

At 10:03 a.m. on February 15, 1974—days after a feature story on the fad ran in the *Auburn Plainsman*—the first streaker was recorded on Auburn's campus.

Wearing footwear and a stocking cap—it was February after all—the unidentified student ran across the Haley Center concourse, leaving onlookers stunned or laughing.

The 1974 *Glomerata* featured a section on a fad that swept the campus that year: streaking. *Used with permission. Auburn University Libraries.*

A photo appeared in the 1974 *Glomerata*, which included the poem:

> *Faster than a speeding bullet;*
> *More powerful than Dean Cater,*
> *Able to dodge Chief Dawson in a single bound;*
> *Look! On the concourse!*
> *In the Quad!*
> *It's—the Streaker!*

The *Plainsman* article was penned by renowned syndicated columnist Rheta Grimsley Johnson, who was editor at the time:

I take credit for accidentally starting the weird streaking fad in the Southeast when, as features editor, I assigned myself a story about the new West Coast fad I'd read about in Time *magazine. The week's theme for the feature section was college fads and shenanigans. To illustrate my story, we paid a staff member's brother to pose as a streaker. A discreet one. The next week we got the call that there would be a "real" streak, which, of course, was the infamous Haley Center one. I never streaked. It was more fun to write about than do, like most things.*

On March 7, "mass streaks" occurred on the Drill Field, on the lawn of President Harry Philpot and on the quad. This time, the groups included women, and the streak "attacks" went on through the night and began again the next weekend, the last before winter-quarter finals. Finally, the craze seemed to have lost steam.

Though the *Glom* writer gives credit to Auburn for helping start the streaking fad, it had actually been going on since the first recorded incident in 1804 at Washington College. However, the fad did not begin occurring in large numbers until the mid-1960s.

TOOMER'S: THE LITTLE STORE ON THE CORNER

Toomer's Corner and Toomer's Drugs are among the most visible and recognized landmarks in Auburn. How, then, did they come to be included in a book about "hidden history"? Because of the story—or in this case, stor*ies*—behind the landmarks.

In February 2011, Toomer's Corner made national news when a man who said he was a fan of the University of Alabama football team claimed he poisoned the famed oaks on the corner, which encompasses the formal entrance to the university and the center of downtown Auburn.

The oak trees, which were planted about 130 years ago to flank the college's main entrance across from Toomer's Drugs, have been central to Auburn tradition for decades. When Auburn wins a game, students and fans converge on the corner and throw toilet paper into the trees in celebration.

Following the national championship win in January 2011, almost the entirety of College Street was rolled in toilet paper—every bush, tree and light post.

So engrained in tradition and beloved are the trees that Auburn fans grieved upon hearing the news that the oaks had been poisoned.

The iconic live oak trees that flank the official entrance to Auburn University were poisoned early in 2011 by a fan of the University of Alabama. Students threw toilet paper into the trees as they traditionally would after a sports victory. Messages were written on some of the rolls of paper. *Photo by Rebecca Croomes.*

Although the rivalry between Auburn and Alabama is one of the most intense in college football, Alabama fans—no strangers to tradition themselves—started a campaign to raise funds to aid or replace the trees. Auburn head coach Gene Chizik and Alabama's Nick Saban appeared together to ask fans for calm. It proved to be a rare moment of togetherness for the two colleges.

Whether the oaks survive, Toomer's Corner will continue to be the site of gatherings, as it has been for more than one hundred years.

What some fans may not know is how the drugstore on the corner and its lemonade become famous and how close Auburn came to losing the beloved landmark.

The Beginning

While Toomer's Drugs is named for Sheldon Lyne (pronounced *line*) Toomer, there is another Sheldon Toomer who had an even larger role in Auburn's history.

The elder Toomer, who was born on June 6, 1836, in Virginia, fought as a captain for the Confederacy. He joined the Third Alabama Infantry Regiment—Company F, the Metropolitan Guard—on April 29, 1861, in Montgomery. About fourteen months later, Toomer was wounded at the Battle of Malvern Hill in Virginia, also known as the Battle of Poindexter's Farm. It was a battle in which Southern casualties were enormous, and most of the Third Regiment was lost. The elder Sheldon had his leg amputated near the battlefield, and he returned home to Auburn.

Sheldon would marry Wilhelmina Lyne Toomer, who was born on July 4, 1841, and had been a teacher in Portsmouth, Virginia, before coming to Auburn. Willie, as she was called, had been born months after the death of her father, a captain in the U.S. Navy, when he was swept overboard in sight of Newport Harbor.

In 1871, the senior Sheldon was elected to the Alabama legislature. Late that year, Willie became pregnant with their first child. Sheldon Toomer wasn't a member of the legislature for long, but he served at a time when the state was considering a location for a new land grant university. In consideration were Florence, Tuscaloosa and Auburn. Toomer and Senator J.L. Pennington made the argument for Auburn and won. East Alabama Male College, a Methodist university at Auburn, became the Agricultural and Mechanical College of Alabama in 1872.

It would be Toomer's last act as a politician. The elder Toomer died on March 26, 1872, of pneumonia. Willie gave birth to a son after her husband's death: Sheldon Lyne "Shel" Toomer, born on July 14, 1872.

The fact that both Willie and her son Shel were born after the deaths of their fathers was a sign to some locals who believed in the supernatural. "In that era, that gave Daddy special powers, magical qualities," said Shel's daughter, Margaret Toomer Hall, who was living in Atlanta in 2011. "People thought Daddy could cure warts and winds and all kinds of things."

Widowed and with an infant, Willie would marry Benjamin Lazurus and live until 1936. She is buried beside the Toomers at Opelika's Rosemere Cemetery.

Shel attended the local college after it was renamed Alabama Polytechnic Institute and played on its first football team in 1892. There, he earned an

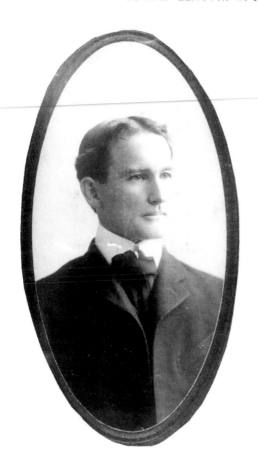

Sheldon Toomer opened Toomer's Drugs in downtown Auburn in 1896. Toomer's father, who had a leg amputated during the Civil War, was instrumental in the legislature's decision to fund a land grant university in Auburn. *Courtesy of Auburn University Libraries.*

undergraduate degree and then a degree in pharmacy. He hoped to open a local drugstore.

In 1896, Auburn was a small, quiet village of fewer than fifteen hundred souls, and nearly half of those were students. The town had dirt streets, no newspaper and no electricity.

In the 1890s, the drugstore owned by Shel's stepfather was for sale, and Shel intended to buy it. He went to a bank in Opelika and borrowed $13,000, Margaret Hall said. "I was told my grandmother said, 'Great God, Shel! There's not that much money in the world. What did you put up?' Daddy said, 'My good name.'"

The small drugstore soon became a place where not only pharmaceuticals were blended and disseminated but also students could buy tobacco, magazines and ice cream.

"Daddy would stay open until ten or eleven at night because that's when the college dances ended, and they would all come by for ice cream," Margaret recalled.

An advertisement for the drugstore in the 1913 *Glomerata* stated:

> *S.L. Toomer*
> *Druggist*
> *"The Store on the Corner"*
> *Headquarters for Cigars, Cigarettes*
> *Tobacco, Soda Water*
> *All the Reading Matter of the*
> *Up-To-Date Variety*
> *Agents for Lowney's and Nunnally's*
> *Fine Candies*

While legend states that John Heisman, the namesake of the Heisman Trophy and one of Auburn's first football coaches, came to the site for lemonade when he coached at Auburn between the store's opening and when he left in 1899, Margaret said she does not recall the store selling lemonade in the early years her father owned it.

However, Tom Eden, who was senior class president in 1949, remembers drinking Toomer's lemonade when he was in college.

About a decade after the store's opening, in 1907, Mr. Shel decided that Auburn was lacking another type of business: a bank. He was one of the founders of what would become AuburnBank, located across from the drugstore. It still operates today in a different location. Mr. Shel owned Toomer's Drugs until 1952, and served forty-five years as bank president and twenty-five as an Auburn city councilman. He also served in many civic organizations, was a member of Auburn's board of trustees and was president of the Auburn Coal and Ice Company.

After World War II, some college officials who were concerned that the University of Alabama was getting a larger appropriation of funds from the state asked Shel to run for the state legislature. At the time, the University of Alabama had many out-of-state students.

"He was not a politician, but he loved Auburn," Margaret said. "His slogan was 'Alabama Money for Alabama Boys.'"

Shel served two terms in the House and then ran for senator. At the time, Lee County and Chambers County "shared" a senator, and when it came time for a resident of Lee County to serve, Shel campaigned. He ran unopposed.

He was a senator in 1945, when a measure came before the state legislature requiring that Auburn and Alabama resume the football rivalry that had been dormant since 1907 because of a dispute over travel stipends. Shel was quoted in the *Tuscaloosa News* on May 30, 1945, as saying, "It is not a matter for the legislature to pass on." The series would resume in 1948 without legislative intervention.

Shel, sometimes spelled "Shell" in newspaper articles of the time, was one of the city's most eligible bachelors and would wait until he was forty-six years old to marry. In 1955, James Powell Cocke Southall wrote in his *Memoirs of the Abbots of Old Bellevue* that "early in life Miss Annie Laurie (not the girl in the song, but her namesake in Auburn) set her heart on Shel Toomer and set her trap for him too, but he eluded her and dashed all her hopes."

Southall also recalled that Shel saved the Abbott home after a candle set a Christmas tree ablaze, writing, "In less than a minute the house would have been in flames and soon afterwards in ashes, had it not been for Shel Toomer, proprietor of the drug-store and the Ward McAllister of Auburn Society who, even more than Mr. Gullatte, the genial and generous grocer, was the most eligible beau in town."

Finally, Shel found the woman he wanted to marry, a visiting Canadian named Florence Maguerite Prendergast, who lived in Birmingham and was teaching languages during summer school at Auburn.

Margaret Hall said her parents met in 1917 or 1918, when Marguerite walked into Toomer's Drugs and said, "Are you the proprietor? Would you call me a taxi?"

Shel knew immediately that this was a "city girl." Auburn had few paved roads, much less taxis to drive on them. Shel was smitten.

The couple married in 1919 and had two children: Sheldon Archer Toomer and Margaret Frances Toomer Hall.

Shel's beloved Marguerite died in May 1956, and he lived another sixteen months without her. Shel died on September 27, 1957, and is buried beside Marguerite at Rosemere Cemtery in Opelika.

When Toomer's Nearly Wasn't

By the time Sheldon passed away, Toomer's Corner, as it had become known, was one of Auburn's well-known gathering spots.

Politicians including Big Jim Folsom, Hugo Black, Lister Hill and George Wallace would hold speeches at the corner; students held pep rallies there, and fraternities initiated members on its sidewalks.

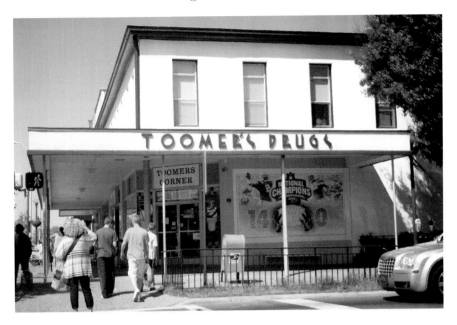

The location catty-corner from the entrance to the university made Toomer's Drugs a popular gathering spot. *Photo by Rebecca Croomes.*

Shel sold Toomer's Drugs to Mac and Elizabeth Lipscomb in 1952, and the Lipscombs kept the well-known name for the next thirty-two years. The drugstore was then sold to Mark Morgan in 1984 and William Beasley in 1992, but the Lipscombs kept ownership of the building.

It was during the Lipscombs' three-decade ownership of the store that the lemonade became known as some of the best in the South.

When Elizabeth "Libba" and McAdory "Mac" first owned the store, Libba helped by doing the accounting. Libba was born in 1928 in Opelika and attended Huntingdon College. She then married McAdory and moved to Augusta, Georgia.

"We came back to Auburn in 1949," said Libba, who still lives in Auburn. "I'd never worked in my life, but I kept the books at the drugstore for several years."

Libba worked at the store until a critical mistake in judgment by Mac: "He brought the books home to me right after I had the baby and put them in bed with me," she recalls with a laugh. "I said, 'That's it.'" Libba and Mac had five children—McAdory Jr., Andrew Denson, Freddie Elizabeth, Nimrod Denson and John Rush—and two sons would eventually own competing drugstores in downtown Auburn. Nimrod owned Toomer's.

Libba recalls that rolling the trees after home games began in the 1960s. "Before that, the celebrations had been for out-of-town games," she said. "I remember when they started rolling it for home games, it made me mad. It was messy, and it bottled up traffic. I wouldn't sell them toilet paper to begin with."

There would be no stopping tradition.

By this time, Toomer's was nationally known and was listed in many magazines as among the most recognizable of college traditions. The City of Auburn installed a webcam that shows the corner continually, including victory celebrations.

Journalist Neil O. Davis of the *Auburn Bulletin* referred to it as "Auburn's Times Square." In 2001, in the wake of the September 11 attacks, *Esquire* magazine listed "162 Reasons It's Good to be an American Man." Number one on the list was Toomer's lemonade. The writer described it: "When God was a little boy and He needed extra money, He put up a card table outside His folk's house. This [lemonade] is what He sold."

By 1999, the store's pharmaceutical sales were declining. Libba Lipscomb, who still owned the building following Mac's death in 1993, was forced to consider selling to other businesses, including a UPS store or flower shop. At the last moment, two Auburn pharmacy graduates, Don and Betty Haisten, came to the rescue and saved the iconic store. The Haistens, who owned a pharmacy in Trussville, had a daughter enrolled at Auburn and kept up with Auburn news. Don saw an ad that Toomer's was for sale. He and Betty, unwilling to let the landmark fade, decided to buy the store and have a manager run it while they stayed in Trussville.

Michael Overstreet, the Auburn graduate the Haistens chose to manage the store, said it has been an incredible opportunity to operate the rescued landmark. "Every day, I meet incredible Auburn people," he said.

The Haistens were responsible for changing Toomer's from a pharmacy into a student hangout and tourist destination, although it still has "Drugs" in the name. The reinvention led to its success. Don, who had worked at a soda fountain in a drugstore in Eufaula as a boy, wanted to install one in Auburn. The Haistens installed equipment to accommodate ice cream and restored as much as possible of its original appearance.

The remodeled store opened on October 7, 1999, and now carries a line called Toomer's Collegiate Collectibles that includes Christmas decorations, mugs and T-shirts, as well as logo toilet paper to throw into the trees outside.

In 2004, the Haistens began bottling the famed lemonade. Don, who received his pharmacy degree from Auburn in 1972 and was a Phi Gamma Delta, died in 2005.

The Trees

The trees at Toomer's Corner are live oaks that are maintained by students in the School of Forestry and Wildlife Sciences at Auburn. Live oaks are not native to Auburn and were initially planted as ornamental trees.

As a fundraiser for the school, students gather acorns that have fallen from the famous oaks to sell each year. The acorns come with a certificate showing that they fell from the Toomer's trees. There are hundreds of Toomer's oaks offspring growing around the country. Following the poisoning incident, scientists from the university worked diligently to leech the poison from the soil.

The man who admitted placing the agricultural pesticide tebuthiuron in the ground, Harvey Updyke Jr., was charged with criminal mischief.

When Updyke took credit for the crime on the syndicated Paul Finebaum radio show, he said he had done so because he heard that Auburn fans rolled the trees in celebration when famed Alabama coach Bear Bryant died in 1983. That rumor, circulated for decades, is untrue. In fact, Auburn-area newspapers, including the *Plainsman*, ran articles praising the legendary coach.

It was allegedly Updyke, calling himself "Al," who told Finebaum, "They're not dead yet but they definitely will be."

Auburn fans have been buying T-shirts by the hundreds to commemorate and help raise money for the trees, many bearing the words "Our Family Tree."

Overstreet said that those who visit Toomer's Drugs remain hopeful that the trees might survive. "But if they don't, they know Auburn will do something pretty classy so that the tradition will continue," he said.

EVER TO CONQUER, NEVER TO YIELD

During football season, in cities across the country and, likely, the world, Auburn's fight song can be heard throughout the day as cellphone ringtones play its tune. Dozens of products play the fight song, titled "War Eagle," including bottle openers, toilet paper holders, car horns, spirit buttons and plush tigers and eagles. A company even once produced clothing with chips sewn in to play the song.

None of those compare with hearing "War Eagle" played by the Auburn Marching Band as its members form the AU logo in the middle of Pat Dye Field at Jordan-Hare Stadium. A voice eighty-seven-thousand-strong sings the familiar lyrics:

War Eagle, fly down the field!
Ever to conquer, never to yield.
War Eagle, fearless and true,
Fight on you orange and blue.
Go! Go! Go!
On to vict'ry, strike up the band!
Give 'em hell, give 'em hell,
Stand up and yell, hey!
War Eagle, win for Auburn,
Power of Dixieland!

If there is anyone wondering why the fight song for the Auburn Tigers is about a war eagle, thank goodness you are reading this book. Even the most patient of Auburn fans gets frustrated when people ask, "Are you War Eagles or Tigers?" (or, heaven forbid, Plainsmen).

Auburn is and always will be the Auburn Tigers. Still, Auburn fans should always take time to educate those who may not understand. For the record, Auburn is not the only university with differing mascots, nicknames and battle cries.

Alabama, the Crimson Tide, has an elephant named Big Al for its mascot.

Beginnings of "War Eagle"

Several legends are repeated in Auburn University's official explanation of the origins of the battle cry "War Eagle." The most often repeated legend was first published by Jim Phillips, editor of the *Auburn Plainsman* in 1960, when an eagle was found and brought to Auburn to serve as a mascot. Phillips thought the use of the phrase "War Eagle" needed some rhyme and reason, given that Auburn already had a tiger mascot.

The tale claims that a Civil War veteran rescued a wounded eagle from a battlefield and nursed it to health. During Auburn's first football game, which was played against Georgia in Atlanta's Piedmont Park in 1892, the eagle took flight, circling high above the field. People called out, "Look, it's a war eagle!"

This didn't stop other legends from circulating about the origins of the battle cry.

Another version states that "War Eagle" was the name given to the golden eagle by the Plains Indians because its feathers were used in war bonnets.

Still another legend stems from a 1913 pep rally before Auburn played Georgia. Cheerleader Gus Craydon said to the crowd, "If we are going to

win this game, we'll have to get out there and fight because this means war."
A student, E.T. Enslen, noticed that something had dropped from the hat of
his military uniform. He bent down to find it and saw it was the eagle pin.
He held it up and said, "It's a war eagle!" The next day, students repeated
the cry in the game against Georgia.

Auburn student Andrew Hopkins handles Nova on the sidelines of the game against
Louisiana State University in 2010. *Photo by Roy Crowe.*

No one knows for sure which, if any, is true. Since the first use, the cry evolved into the title of the university's fight song, as well as a greeting. It also has become embodied by the regal rescued eagles that fly before Auburn's home football games.

People who visit Auburn to watch their favorite team play the Tigers often say they are surprised at the number of people walking along the street, giving a wave and a "War Eagle" greeting.

People outside of Auburn will say "War Eagle" when they see someone wearing an Auburn shirt or sporting an Auburn car tag. They will say it before they hang up the phone or write it when signing off an e-mail or text, often abbreviating "WDE," for "War Damn Eagle!"

This usage of "War Eagle" as a greeting and sign-off has grown steadily since the fight song was penned in 1954. At the time, the fight song for the Alabama Polytechnic Institute, which was often referred to as "Auburn," was "Auburn Victory March." One Auburn alumnus, Roy B. Sewell, affectionately known as "Mr. Auburn," didn't think the staid march suited Auburn's increasing power on the football field.

Former athletic director David Housel shared a 2009 column in which he wrote of the song's origins in 1954:

> *That year was highlighted by a stunning 14–13 win over sixth-ranked Miami in Birmingham when all of Auburn's points came in a dominating fourth quarter against the mighty Hurricanes. And there was the equally dominating 33–13 win over highly regarded Baylor in the Gator Bowl. Roy Sewell, one of Auburn's most loyal and generous alums, thought Auburn needed a new fight song to celebrate this return to glory.*

With permission from API officials, Sewell took an unparalleled step. He contacted professional composers Robert Allen and Al Stillman and paid for their composing services.

Why? The *Rome News-Times* in Georgia quoted Sewell, during a speech given when he was being honored in 1978, as saying: "I love Auburn. I've loved Auburn for as long as I can remember. And I love all the Auburn people."

Composer Robert Allen's widow, Patty Allen of New York, said it was very unusual for composers to be asked to write a college fight song. "At the time, he was one of the most popular songwriters in the world," Patty said of her husband in 2011.

The listing for the song "War Eagle" seems incongruous among the duo's hit songs, such as "There's No Place Like Home (For the Holidays)" and

"Chances Are." And yet, it was the perfect pairing of professional musical talent and the talent being nurtured at Auburn.

The Composers Who Served a "Peach"

Robert Allen was a pianist, arranger and writer who often teamed with Al Stillman, a lyricist. The duo composed hits for Perry Como, Johnny Mathis, Pat Boone, the Four Lads, Tony Bennett, Doris Day and many other popular singers of the day.

Allen was born on February 5, 1927, and died on October 1, 2000, in Quogue, New York. He and Patty had four children: Gordon, Pamela, Diana and Katie. Before his death, Allen received the ASCAP Foundation's Lifetime Achievement Award in pop music.

Al Stillman was born in New York City on June 26, 1906, and died in 1979. In 1933, he became a staff writer for Radio City Music Hall, a position he held for nearly forty years. He also collaborated with other well-known composers, including George Gershwin.

Roy Sewell asked the team to write a song "to express the spirit which has sparked the Tigers' amazing football comeback." When it was completed, Sewell told Auburn officials it was "a peach of song."

However, the song was not initially popular with everyone.

Housel said he heard from alumnus Kenny Howard the details of the day Sewell introduced the song to Shug Jordan:

> Mr. Roy excitedly came to Coach Jordan's office ready for him to hear the new song he had commissioned for the now nationally prominent football team. Kenny was among several people Coach Jordan called into his office to hear the new song…Coach Jordan, not wanting to disappoint his old friend and perhaps Auburn's greatest supporter, said something like, "Well, it's okay" or "It's pretty good," something to that effect.

Sewell took that as affirmation, and "War Eagle" became Auburn's new fight song, Housel said. "Over the years, 'War Eagle' became the tune by which Auburn is known, its battle hymn and war cry in one, sweeping all other Auburn songs of that day, 'Fight 'em Tigers,' the 'Auburn Victory March,' 'Samford Tower' and 'Hail to Auburn,' into virtual oblivion. Only 'Glory, Glory to Ole Auburn' remains."

A 1955 editorial published in the *Montgomery Advertiser* stated, "But imagine, if you can, in either supreme victory or utter defeat, Auburn's uncontainable

spirit being vented in these driveling lines. This insipid, anemic attempt to versify one of the supreme bellows of our time is just plain tragic…It's for the Ladies' Aid Society, not Auburn."

A writer at the *Lee County Bulletin*, however, thought "War Eagle" was "a fighting song expressing in music the undaunted spirit of today's revitalized Tigers."

Auburn students strolling along the historic campus can hear the fight song daily. The carillon in the Samford Hall clock tower plays it each day at noon.

The fight song can be downloaded these days from any website as a ringtone or tract for an iPod. In the late 1950s, forty-five rpm records were sent to people who joined the Alumni Association. By the 1970s, fans could buy the song on vinyl. Bluegrass musician Glenn Tolbert recorded "War Eagle," as well as the fight song for the University of Alabama, in a Muscle Shoals sound studio.

Bluegrass musician Glenn Tolbert recorded "War Eagle," as well as the fight song for the University of Alabama, in a Muscle Shoals sound studio. *Courtesy of Jeremy Henderson/ thewareaglereader.com.*

The Eagles' Flight

In America, an eagle represents freedom and the hard-fought battles it takes to maintain it. At Auburn, the flight of the eagle represents courage in battle, grace in power and pride in teamwork.

When one of two current eagles that fly at Auburn makes its pregame appearance, attendees—even those for the opposing team—are often brought to tears.

The first eagle made an appearance on the sidelines at Auburn's home football games in 1930 and stayed until its death later that year. Another eagle was not found until 1960, and since then, eagles have been present at games continuously. The now famous pregame flights didn't begin until 2000.

The eagles are under the care of the College of Veterinary Medicine's Southeastern Raptor Center with approval from the U.S. Fish and Wildlife Service. The eagles and other birds of prey are used for educational programs. All of the current birds—at differing times including hawks, falcons, owls and a vulture—are kept at the center because they were injured or born in captivity and would not be able to survive in the wild.

However, that was not the case initially. The first eagle mascot was discovered in November 1930 in Bee Hive, Alabama. Onlookers said the golden eagle had swooped down to attack its Thanksgiving dinner, a turkey, and had gotten tangled in some vines. A story in the *New York Times* published on November 29, 1930, stated, "The eagle was turned over to the Auburn football team and the players decided that since their battle cry is 'War Eagle,' they would make a mascot out of the bird."

The 1931 *Glomerata* shows a photo of the majestic bird, flanked by Auburn's cheerleaders "Happy" Davis and "Bull" Stiers, who helped care for it.

The eagle is credited with putting Auburn's football team back on track. During its first appearance, Auburn beat South Carolina 25–7, winning its first conference game in four years.

The bird was referred to as "War Eagle" and at some point was designated "War Eagle II," with the legendary 1892 eagle listed as the first.

Since then, each bird that is named the "official" university eagle is given the title War Eagle in addition to its nickname. Auburn's third eagle was captured by a farmer in his cotton field in Talladega County in November 1960. It was donated to Auburn, where it was taken to the Alpha Tau Omega fraternity house. The fraternity brothers would be keepers of Auburn's eagles until the birds came under federal regulation and the Southeastern Raptor Center was founded.

War Eagle III was nicknamed "Tiger." In June 1963, Tiger escaped its cage but soon was found in a nearby field. Another escape in 1964 would not end as well. Tiger was found dead of a shotgun blast in Gardendale, where it had been staying with a student. The incident was published in newspapers across the country.

Within weeks, another golden eagle was found to take the place of War Eagle III. With the help of the Birmingham Downtown Action Committee, the eagle was located in a zoo in Jackson, Mississippi. War Eagle IV, also nicknamed Tiger, lived in an aviary built on Auburn's campus and named for one of War Eagle III's trainers, A. Elwyn Hamer Jr., who died in a plane crash in 1965.

War Eagle IV made headlines in 1976 for its actions during Auburn's game against Florida, earning it a spot in the 1990 Football Hall of Shame for "Silliest Performances by Mascots."

Sports Illustrated writer Franz Lidz gave the following pun-filled description in the October 28, 1991 edition:

> *Auburn's war eagle wouldn't take defeat flying down. When Florida wide receiver Wes Chandler scored a touchdown against the Auburn Tigers in 1976, the bird took things into its own talons. It took off from its perch and blindsided Chandler in the end zone, thus becoming the only mascot to draw a 15-yard penalty for unnecessary pecking.*

Florida would win the game, 24–19, but War Eagle IV won the hearts of Auburn fans that day.

War Eagle IV died of natural causes in 1980, on the morning of the Iron Bowl. The *Tuscaloosa News* reported its death on December 3, 1980, under the headline: "As If Auburn Didn't Have Enough Troubles Already."

Its replacement was located in Wyoming and brought to Auburn on March 3, 1981. Under the Endangered Species Act, War Eagle V was allowed by the federal government to remain in the care of Auburn University's Veterinary Medical School. The eagle, also nicknamed Tiger, died in 1986 of a ruptured spleen.

The golden eagle to take its place, War Eagle VI, was one of the most iconic of Auburn's eagles. It was the first to make the majestic pregame flight and continued to do so until it retired in 2006 to live in the Raptor Center.

In 2002, Tiger flew during the opening ceremonies of the Winter Olympics in Salt Lake City.

Auburn student Scott Clem poses with Spirit before a pregame appearance in 2010. *Photo by Marianne Hudson.*

Nova, the current eagle, is War Eagle VII. All official eagles have been golden eagles. Spirit, the bird that shares pregame duties with Nova, is the university's first bald eagle.

On November 11, 2006, Nova made its debut flight as War Eagle VII during the Georgia game. Born in captivity in the Montgomery Zoo in 1999, Nova came to Auburn when it was six months old. Spirit's first game flight was in 2001. It was discovered as a fledgling in Florida in 1995, unable to hunt for food because of a deformed beak.

BRINGING AUBIE TO LIFE

In early March 1979, Auburn University's mascot, Aubie, led cheers and called out an enthusiastic "War Eagle!" at Toomer's Corner. They were the last words Aubie spoke. Inside the day-old tiger costume was student James Lloyd, who was the spirit director in the student government that year.

In the days that followed Aubie's first appearance, an unspoken decision was made that Aubie, a costumed version of the university's longtime cartoon mascot, should not and would not speak. He never has again.

Lloyd, the student who had the idea to bring Phil Neel's cartoon drawings of Aubie to life, was the first to wear the costume, choosing to debut Aubie at the SEC championship basketball tournament at the Birmingham Jefferson Civic Center the day after the costume was delivered. Official university records show that Aubie was at the tournament on February 28, 1979, and Lloyd recalls being there the next day during the game against Georgia, a game that went into four overtimes and remains the longest in college basketball history. Auburn won.

Aubie made his first appearance as a costumed mascot in 1979. *Courtesy of James Lloyd.*

"It was so hot inside that suit," Lloyd recalls.

Upon his return to Auburn, Lloyd joined students who were celebrating the team's win at Toomer's Corner. The mascot received a warm welcome from students, and one of Auburn's greatest traditions had begun.

The Birth of Aubie

Phil Neel was working as a cartoonist for the *Birmingham Post Herald* in the 1950s when he was approached by officials from Auburn University, then API, to design covers for football programs. The first drawing appeared on the program for the 1959 game against Hardin-Simmons.

"I started out using a tiger on the covers," Neel said of his early drawings. "They evolved into a standup animated kind of figure." By 1962, Aubie was standing; the next year, Neel drew the tiger wearing clothes. As the tiger took on human qualities, Neel decided he needed a name.

"I labeled him Aubie. [Athletic Director] David Housel told me then, 'That's going to stick,' and he became Aubie," Neel recalled.

Aubie developed a personality, becoming an impish character who was adored by fans. "I would make these drawings where he was doing something to the mascot of the other school," Neel said.

Over the course of eighteen years, Neel drew about 150 covers for Auburn. "I started off doing it for tickets and things, and then later I got paid a small amount," he said. "I've been very happy having that connection with Aubie."

In fact, Neel's connection with the university would be a lifelong relationship. His sons, Rick and Mike, played for Auburn's football team—Mike was the captain of the team during the famous 1972 "Punt, 'Bama Punt" game—and his daughter, Cindy, also graduated from Auburn.

All three of Neel's children received Auburn's top award for service, the Algernon Sydney Sullivan Award. When the university began using photos as program covers, Neel's cartoons were no longer needed. However, a cult following began. Auburn fans covet the collectible Neel drawings.

He's Got Personality

Aubie was already twenty years old when James Lloyd decided this personable, two-dimensional character needed life. Mascots were not new to college sports, but costumed mascots were relatively few in the 1970s.

The first record of a college adopting a live mascot was Yale University in 1889, which had an English bulldog named "Handsome Dan." In the 1950s, Virginia Tech, which went by the "Gobblers," had a turkey mascot. The college began using a costumed Gobbler in the fall of 1962, but the school would eventually ditch the turkey image and become the Hokies.

Beginning in 1957, the University of Florida kept a live alligator named Albert on the sidelines. The costumed gator first took the field in 1960.

In fall of 1978, Lloyd began asking Auburn officials about getting a tiger costume. He and members of the Spirit Committee also approached the Alumni Association.

"At that time, our football team was really terrible, and there was nothing going on at Auburn athletically," he recalled. So Lloyd took out his old Phil Neel programs and asked the Alumni Office to get approval to use the name and the appearance.

Neel recalls that while he did not want to design the costume, he was happy to give permission to bring his Aubie to life.

"I told them to just go from the drawings," Neel said. "He doesn't look exactly like my Aubie, but he's close enough."

Lloyd called Disney World and asked where the company ordered its costumes. He then contacted the famous Brooks–Van Horn Costume Company in New York. He was told the costume would cost $1,350.

"I think I had a budget of about $400 that year," Lloyd said, "and that was to buy balloons and trophies and host pep rallies and the Wreck Tech Parade. I was trying to find money to pay for the costume without much success. Julian Holmes, who was assistant director of the Alumni Association, said if we couldn't get the money he'd pay for it."

Holmes, who had played football for and graduated from Auburn in the 1950s, was one of the university's most loyal supporters and was determined to make the students' dream of a mascot a reality. Lloyd said Brooks–Van Horn sent fabric swatches and designed the costume from Neel's drawings, shipping the first costume in late February 1979.

"I put it on and went down and walked around the cafeteria and Foy Student Union," Lloyd said. "The press came over and took photos. The students loved it. The next day, Auburn was playing in the SEC basketball tournament in Birmingham, and I wore it to the game that night."

Lloyd got another surprise that night. "Auburn's Jefferson County Alumni Booster Club was meeting that same night [as the game], and they raised enough to pay for it," he said.

The first Aubie costume cost $1,350 and was made of thick fabric that made life difficult for those who portrayed the mascot during football games in early fall, when temperatures in Auburn remain summer-like. *Courtesy of James Lloyd.*

"When we won again, I wore it to Toomer's Corner. They rolled the trees and raised me up on people's shoulders, and I was leading cheers. Then Aubie said, 'War Eagle!' and that's the last time he ever spoke."

Now, Lloyd faced a new challenge. As soon as basketball season ended, spring training and cheerleader tryouts began. Lloyd knew he needed a student, or students, to portray Aubie during the next season.

"I was head judge to pick the cheerleading squad for the next year, and I held Aubie tryouts for the next year," he said.

He interviewed students to ensure they had the personality to embody Aubie. When the tryouts were over, Barry Mask was named the first Aubie. Mask, born in 1959 in Alexander City, was president of his fraternity, Phi Kappa Tau, and co-founder of the Shug Jordan/Dean Katherine Cater Leukemia Fund.

Runners-up who would help portray Aubie during the year were Bob Harris and Vicki Leach, the only female ever to wear the suit.

"We tried to give him three traits," Mask said. "Be a good dancer, have the cool persona of Pink Panther and he had to be a ladies' man. Those three things have stayed."

Mask felt the weight of the challenge and knew he had to come up with a surprise and standout debut for Aubie.

"We had bought a big refrigerator at the frat house, so I took the box and painted it orange and blue," Mask said. On September 5, 1979, Mask sat inside the box on a sideline corner where students could see the oversized gift and wonder, "What the heck is in that box?"

"I think the game was at noon, and it was a blistering summer," Mask said.

The first suit was much heavier than the ones Aubie wears today.

"I sat in the box with the head off, drinking cups of water," Mask said. "It was about an hour and twenty minutes before kickoff, and I was just baking."

Then, just before game time, the cheerleaders carried the large "gift" to the fifty-yard line, where the band also gathered. Announcer Carl Stevens told the crowd that Auburn was beginning a new tradition, and Mask popped out and danced with the band.

"Then I hurried back under the stadium because I was about to pass out," Mask said.

His reaction to the heat wasn't obvious to fans and students, who loved Aubie's playful antics. Over time, the antics grew, and as more colleges added mascots, Mask would plan a skit with the other team's mascot.

Lloyd and Mask remember that their creation also had an impact on the school's biggest rival, the University of Alabama. In the late 1970s, Alabama's team was already known as the Crimson Tide, after a sports writer described its dominance on the field. But 'Bama did not have a mascot.

Before the 1979 Iron Bowl at Legion Field in Birmingham, the legendary Bear Bryant was quoted as saying he'd have to go back to Arkansas and plow if his team lost to Auburn. When Aubie took the field that day, he was wearing Bear's trademark, a houndstooth cap, and pushing a plow—much to the delight of Auburn fans, who were chanting, "Plow, Bear, Plow."

Although Auburn would lose the game, the next morning, newspapers across the state featured photos of the irrepressible Aubie on their front pages.

"I was told after Bear Bryant came back from the game where he first saw Aubie, he said, 'We need one of those,'" Lloyd said.

Mask continued with his antics when Aubie traveled to Atlanta's Grant Field to play Georgia Tech. "They used to let freshmen come out on the field and make a gauntlet for the Tech team to run through," Mask said, adding that he later heard Tech students had "put a bounty on Aubie's tail."

"There were about 150 or 200 students on the field and they charged me and ran down to the end of the field. They came over the fence to get me,"

he said. "All kinds of fights broke out. It delayed kickoff and everything. That sort of put Aubie on the map."

Aubie was a "public relations coup," Mask said. "That zany stuff got us in the papers."

In late October, the spirit director from the University of Alabama called and asked how to get a suit to create a mascot for the university. Lloyd and Mask gave him the contact for Brooks–Van Horn, and 'Bama's mascot, Big Al the elephant, would debut in 1980.

The Legacy

These days, Aubie's effervescent personality is intact, but he has become a more contemporary character, with various suits, including one adorned with tiger-striped dreadlocks.

At the age of nine, the author's daughter, Shannon Kazek, was introduced to Aubie at a 2002 football game. *Author's collection.*

In addition to appearances at a variety of sporting events, the people who portray Aubie attend a variety of high-profile functions each year. He also appears at five to ten community events each week, such as visits to senior centers and schools.

Aubie competes annually in the Mascot National Championship, winning six national titles in 1991, 1995, 1996, 1999, 2003 and 2006. Michael Jernigan, Chris Wood and Rob Thompson brought home the first title in 1991.

In 2006, Aubie was inducted into the first class of the Mascot Hall of Fame and has been named to the Capital One All-American Mascot Team in 2003, 2004, 2005, 2006 and 2008. He has been featured in *Sports Illustrated* as one of "The Top 10 Hot Mascots" and has spun the wheel with Pat Sajak and Vanna White on *Wheel of Fortune*.

Phil Neel said that two of the people who portray Aubie recently came to his Birmingham home to meet the iconic cartoonist. Neel said he is always happy to be recognized for his contribution to the university.

"Aubie's been a big part of my life for a long time," Neel said. "I'm thrilled about him."

Mask, too, enjoys the Aubie legacy. Since graduating from Auburn in 1983, Mask has had a successful career and was elected to the Alabama House of Representatives in 2006.

In 2009, the *Opelika-Auburn News* featured a story on Mask on the anniversary of Aubie's debut. Danny Richards of Dothan, who portrayed Aubie in 1981, said Mask was a trailblazer.

"Barry came up with things that are still used today, including the 'Aubie Autograph,'" Richards said. "He had nothing to base anything on because he was the first, and that's why he is so important to the creation of Aubie."

Auburn Achievers

Since its inception as East Alabama Male College, Auburn University has educated many students and employed faculty who have gone on to achieve great things—politicians, athletes, actors, writers and musicians who have left their marks on the world.

While they are too numerous to list here, the partial list below—along with comments from some renowned alumni—includes the names of some of the standouts who walked the Auburn campus. The years they graduated, attended or coached follow each name.

ASTRONAUTS

When JAN DAVIS transferred from Georgia Tech to Auburn in 1975 and enrolled in mechanical engineering, she discovered she was often the only female in her classes.

"When you're the only woman in class, they're all watching you to see if you can handle it," she said. Davis found the professors and other students supportive, though, and completed her degree in 1977, hoping to find a job in the petroleum industry.

She ended up as one of the country's first female astronauts.

After Auburn, Davis went to the University of Alabama in Huntsville to get her master's and doctorate degrees. She worked at NASA's Marshall Space Flight Center as an aerospace engineer and was made an astronaut in 1987.

She flew on three missions, logging 673 hours in space.

She remembers the days when she spent time at the Sani-Freeze and went to see free movies in Langdon Hall. These days, Davis shows her love of Auburn by serving the university, on both the Alumni Association board and engineering alumni board.

Other astronauts include:

- HANK HARTSFIELD, 1954, astronaut
- CLIFTON WILLIAMS, 1954, Project Gemini astronaut, test pilot
- KEN MATTINGLY, 1958, astronaut, *Apollo 13* (pulled), *Apollo 16* spacewalk
- JAMES VOSS, 1972, astronaut, veteran of five space flights, International Space Station
- KATHRYN THORNTON, 1974, astronaut, second U.S. woman in space, spacewalk

ATHLETES, OLYMPIANS AND COACHES

Although Auburn University is known for its football program, in more recent years it has become a powerhouse in swimming and diving and makes great showings in many other sports. Auburn has had eighty-one students or graduates who have competed in the Olympics, including twenty-seven gold medalists: Rowdy Gaines, three gold medals, 1984, swimming; Charles Barkley, 1992, 1996, basketball; Harvey Glance, 1976, track; Ruthie Bolton, 1996, 2000, basketball; Willie Smith, 1984, track; Scott Tucker, 1996, swimming; John Hargis, 1996, swimming; Kirsty Coventry, 2004, 2008, for Zimbabwe; and Cesar Cielo, 2008 for Brazil.

Auburn's swimming coach, David Marsh, coached several Olympic teams and led Auburn to ten national swimming and diving titles.

More than 250 athletes have gone on to play pro football, and 62 have been named All-Americans. Eleven coaches and players were named to the College Football Hall of Fame.

At least twenty-three basketball players have gone on to the NBA, including Charles Barkley, the most visible of Auburn's basketball alumni.

Auburn's baseball team has competed in four College World Series (1967, 1976, 1996 and 1997), and forty-five baseball players have played professional ball.

Female athletes made great strides in the 1970s, after Title IX was passed. Olympian RIETA CLANTON recalls those days.

Growing up, Reita Clanton would play any game with a ball. With few opportunities in organized sports for girls, Clanton, born in 1952, would play outdoors, joining girls until they grew older and lost interest and then competing with boys.

She dreamed of being an athlete. Auburn University gave her that chance.

When she arrived on campus in the 1970s, Reita was ecstatic. The passage of Title IX allowed women the opportunity to compete.

"I was so starved to play, I played everything," Reita said. She would win records for Auburn in volleyball and basketball and played in softball leagues in the summer.

It wasn't until her time at Auburn was nearly over that the female athletes began to question inequities. "We started wondering why the guys were playing at the coliseum and we were playing in the old Barn." The push for equality had begun. "We owe a debt of gratitude to the women in the physical education department at the time," she said.

Reita graduated in 1974, thinking that her time as a competitor had ended. She was mistaken. An Auburn coach forwarded Reita a letter that would change the course of her life and take her to Olympic competition.

The letter stated that the United States hoped to form a women's handball team and was looking for recruits. Reita had no idea what the sport entailed but headed to the training sessions and tryouts. She discovered a love for the sport, which was played much like soccer, only using hands to advance the ball to the goal.

In 1984, Reita and the U.S. team headed to Los Angeles to compete. She then decided to coach, acting as assistant coach at the 1996 Olympics and head coach in 2000.

She was inducted into the Alabama Sports Hall of Fame in 2010.

During her career, she traveled to twenty-six countries.

"I never would have known myself as an athlete if I hadn't learned handball," Reita said.

These days, Reita is busy with Living from the Inside Out, a program to inspire children to reach their full potential.

MARGARET HOELZER, who in 2008 won two silver and one bronze medal for the U.S. Olympic swim team, is one of the women who benefited from female trailblazers such as Clanton. Hoelzer said that despite the dominance of football, the swim team at Auburn always felt supported.

"I was on three national championship teams while I was at Auburn. The swim team is not a big sport at other schools, but the entire town embraced and supported us. It was a wonderful thing."

The swim team, she said, has its own words to Auburn's fight song, "War Eagle."

"At the end, instead of 'power of Dixieland,' we sing 'power of sea and land,' to refer to the swimmers and divers," she said. After championship wins, the entire team would jump in the pool and, joined by the coaches, sing this version.

Hoelzer, who graduated in 2005 and retired from swimming in 2010, revealed in 2008 that she had been sexually abused as a child and became spokeswoman for the National Children's Advocacy Center.

She is pursuing a doctorate in hopes of helping children in similar situations.

Hoelzer said that her love for Auburn will never change. "Family is the best description there is for Auburn," she said. "I don't know if people on the outside truly get it. There's such a bond."

Here are a few of the other prominent athletes from Auburn:

- WALTER GILBERT, 1930s, three-time All-American, NFL player, College Football Hall of Fame
- TUCKER FREDERICKSON, 1964, All-American, NFL, College Football Hall of Fame
- TERRY BEASLEY, 1971, All-American, NFL, College Football Hall of Fame
- TRACY ROCKER, 1988, Lombardi and Outland Awards, NFL player, Tennessee Titans defensive line coach, Hall of Fame
- ED DYAS, 1960, College Football Hall of Fame
- PAT SULLIVAN, 1972, Heisman Trophy winner, NFL, College Football Hall of Fame
- VINCE DOOLEY, 1954, master's 1963, University of Georgia football coach 1964–88, athletic director 1979–2004
- BO JACKSON, 1992, Heisman Trophy winner, former professional football and baseball player, College Football Hall of Fame
- ROWDY GAINES, 1982, Olympic gold medalist in gymnastics, world record holder and television sports commentator
- CHARLES BARKLEY, 1984, named to eleven NBA All-Star teams, Olympic gold medalist and television sports commentator
- REX FREDERICK, 1959, retired jersey, basketball, set record as all-time leading rebounder with 14.3 rebounds per game average
- CHUCK PERSON, 1986, NBA forward, 1987 NBA Rookie of the Year; Auburn jersey retired
- JOHN MENGELT, basketball, Auburn jersey retired

- WESLEY PERSON, 1994, retired jersey, basketball
- FRANK THOMAS, 1989, played football and baseball, university record of forty-nine home runs, professional baseball player, winner of the Ted Williams Award, two-time MVP
- CAM NEWTON, attended 2010, Heisman Trophy winner, national championship quarterback

Some of Auburn's greatest coaches include:

- RALPH "SHUG" JORDAN, 1932, football coach 1951–75, amassed most wins in Auburn history, College Football Hall of Fame
- JIMMY HITCHCOCK, 1932, pro baseball player, former Auburn assistant football coach, head baseball coach, Hall of Fame
- MIKE DONAHUE, 1904–06, 1908–22, second "winningest" coach in Auburn history, College Football Hall of Fame
- JOHN HEISMAN, coach 1895–99, College Football Hall of Fame, namesake of the Heisman Trophy

PAT DYE, who was a two-time All-American while playing football for the University of Georgia in the late 1950s, was one of Auburn's most successful coaches, leading the team from 1981 to 1992. Dye, who remains connected to the university, said that having the field at Jordan-Hare Stadium named for him in 2005 was "the greatest honor my name's ever been associated with. There's been nothing even close." Dye also has been inducted in the College Football Hall of Fame.

Dye played pro football for the Canadian league after leaving Georgia and then was an assistant coach under Paul "Bear" Bryant at the University of Alabama.

Although Pat Dye had ties to two of Auburn's biggest rivals, he came to love Auburn because of the quality of its students. "The right kinds of students come here," he said. "It shows in their character."

Dye said that Dr. George Petrie, who formed Auburn's first football team in 1892 and wrote Auburn's Creed, had more influence on the university than anyone before or since. At varying times until his retirement in 1942, Petrie was professor of history and Latin, head of the History Department and dean of the graduate school. He was the first person in Alabama to earn a doctorate degree.

"He was a great guy who understood that the mental, physical and spiritual were all part of a student's development," Dye said.

When Dye arrived at Auburn in 1981, the university's infrastructure was in need of repair and expansion. One expansion project would help increase Auburn's presence in athletics. "The most significant decision was made after we lost to Alabama in 1984—to add more seats to the stadium," Dye said.

The project, completed in 1989, added fifteen thousand seats and sixty-nine skyboxes, the first of their kind in the SEC. It allowed more games to be played in Auburn, including the first-ever home game against Alabama, which was played in the fall of 1989.

The expansion made Jordan-Hare Stadium the largest in the state until Bryant-Denny Stadium was expanded in 2006.

Dye said when he considers Auburn's success, he thinks of one phrase: "'Auburn family' stands out in my mind," he said. "Bricks and mortar don't make things happen. People make things happen. Auburn is what it is today because of the faculty and administrators who choose to teach here and the students who choose to come here."

WRITERS, JOURNALISTS

RHETA GRIMSLEY JOHNSON, class of 1977, led an underground existence while at Auburn. As editor of the student newspaper, the *Plainsman*, she spent much of her spare time working:

> *The basement of Langdon Hall was my home most of my time at Auburn, until they moved the* Plainsman *office to the new Student Union building. Then I moved with it. Until then I was Boo Radley, spending more time in that basement than I did in class or in the dormitory or anywhere else.*

Johnson, who would go on to become an award winning syndicated columnist and author, recalls that the student government association would screen free films in the upstairs auditorium:

> *Occasionally, I'd come up from the basement for the free student union movies on the main floor of Langdon. I first saw* Casa Blanca *there, and* The Pink Panther. *Lots of times I'd be writing in the basement while the Roadrunner cartoons were playing overhead, and I could hear the clapping and foot-stomping and experience the fun vicariously.*

Rheta and the hardworking staff won the prestigious National Pacemaker Award in 1975. She has fond memories of those days:

> *The* Plainsman *staff was my family, my fraternity, my fun. I lacked for nothing. The year I was* Plainsman *editor, because of my feminist rants, everyone thought I was some kind of fearless crusader, a ball-busting libber. I was only brave in print. I got married in December my senior year. Nobody much knew that. I quit going to classes altogether about that time. It was all I could do to get the newspaper out on time. I came back to Auburn two years later, took twenty hours one quarter and graduated.*

Other Auburn writers and journalists include:

- CYNTHIA TUCKER, 1976, syndicated columnist *Atlanta Journal-Constitution*, Pulitzer Prize winner
- ANNE RIVERS SIDDONS, 1958, bestselling author of southern fiction
- JIMMY JOHNSON, 1974, cartoonist, "Arlo and Janis"
- BILL HOLBROOK, 1980, cartoonist, "On The Fast Track," "Kevin & Kell"
- WAYNE FLYNT, AU professor emeritus, author of eleven books (two were nominated for the Pulitzer Prizes, including *Poor But Proud: Alabama's Poor Whites*)
- ACE ATKINS, 1994, author and Pulitzer nominated journalist
- JAMES REDFIELD, late 1960s, author of *The Celestine Prophecy*

PERFORMERS

Auburn University was on the cusp of change in 1969. The historically conservative campus had begun integrating—the first black student graduated in 1967—and pockets of students, though in the minority, were holding protests against the Vietnam War.

It was in this atmosphere that eighteen-year-old Michael Wilson of Montgomery arrived on campus. The shy student was in the first group of students to attend class in the newly built Haley Center, taking a Western Civilization class in a large room with theater seating. "It was huge," he recalls. "I'd never seen a class that size."

Wilson, who would take the name O'Neill when he began his unlikely career years later, remembers signs hanging from the walls of Haley Center

promoting the Vietnam Moratorium, a nationwide protest movement to end the conflict.

As some students organized protests, others organized blood drives to help wounded soldiers. Some young men were attending college as a way to avoid being drafted into the military. The freshmen entering in 1969 would be the last class to be issued deferments.

MICHAEL O'NEILL was told that as long as he stayed in college, he would not be drafted. Then, in November, O'Neill received a letter saying that his eligibility to fight had been extended until the last day of March. He was issued the number sixty-one in the draft.

"By the thirtieth of March, they had reached number fifty-eight," Michael said. He would never be required to fight. "The war was beginning to wind down."

As the first in his family to attend college, Michael could have chosen any school. But he had loved Auburn since his father took him to a game against Florida when he was eight years old. "Once pickled, you can never be a cucumber again," he says of becoming an Auburn fan.

By the time he arrived, integration and the war seemed to broaden students' horizons. Speakers invited to campus included Gloria Steinem, Ted Kennedy and Muhammad Ali.

"I was a kid from Montgomery who didn't know anything," Michael said. "I was exposed to new ideas."

He joined the fraternity Lambda Chi Alpha, enrolled as an economics major and got involved in campus politics. He was elected vice-president of the Student Government Association, serving in a time of panty raids, streaking and the relaxing of women's strict curfews.

"It was a different world," he says.

It was Michael's fraternity involvement that would lead him down an unusual career path. After receiving a prestigious national award from the fraternity, Michael was required to give a speech. "Unbeknownst to me, they recorded it. I apparently hit the mark in terms of the fraternity experience."

The tape was sent to presidents of other colleges and used to encourage Lambda alumni to donate. One of those who viewed the tape was Will Geer, the veteran character actor who played Grandpa Walton on *The Waltons*.

Geer called Michael. "He said, 'Son, I think you should try acting before the corporate structure snaps you up. Come to California and I'll work with you. I think he was just a guy who liked to stir things up."

Michael asked the advice of Ed Lee Spencer, who ran the local lumberyard. Spencer told him, "You probably won't make it, but you have to go."

So Michael went. When he received his Screen Actors Guild card, he changed his name to O'Neill. Geer's daughter, Ellen, gave him his first acting lessons, but he soon realized he needed more training. He studied for years in New York before returning to California. He has worked steadily as a respected character actor ever since, acting in films such as *Transformers*, *The Legend of Bagger Vance* and *Traffic* and on TV shows such as *Grey's Anatomy* and *Fringe*. Michael has worked with actors such as Matt Damon, Robert Duvall, Al Pacino, Andy Garcia and Clint Eastwood.

"I was really fortunate," O'Neill says of his college experience and subsequent career. "A window is open in those years that really are not open again."

Other Auburn performers include:

- JIMMY BUFFETT, 1964, attended Auburn and graduated from University of Southern Mississippi
- TAYLOR HICKS, 1998, winner of *American Idol* in 2006
- BIG BILL MORGANFIELD, 1980s, blues singer and guitarist, son of Muddy Waters
- VICTORIA JACKSON, attended Auburn, comedian on *Saturday Night Live*
- OCTAVIA SPENCER, 1983, actor, *A Time to Kill*, *Big Momma's House*, *Spider-Man*, *Ugly Betty*

OTHERS

Auburn also has produced numerous political and cultural figures, although the state representatives and senators are too many to name here. One of the most influential graduates is Jimmy Wales.

Doris Wales's husband, Jimmy, wasn't sure what she was thinking when she bought a set of World Book Encyclopedias from a traveling salesman in 1968. After all, their firstborn son, also named Jimmy, was not yet three. But Doris, an educator, wanted her son to have access to knowledge.

Today, Mrs. Wales's purchase seems predestined.

JIMMY "JIMBO" WALES was listed in 2006 on *Time* magazine's list of 100 Most Influential People as founder of Wikipedia, the online encyclopedia that has more than 1 million entries and has changed the way people share information.

Born in Huntsville, Alabama, in 1966, Wales was taught in his childhood by his mother and grandmother, Erma. The women owned and operated House of Learning Elementary School, where as few as four students might be enrolled in each grade. At the time, Huntsville had come into prominence as

the incubator for missile development at Redstone Arsenal and space research at Marshall Space Flight Center, which opened as a NASA facility in 1960.

Wales was one month shy of his third birthday when Neil Armstrong walked on the moon in 1969, and the excitement of living in the Rocket City stayed with him.

"One of the things I remember was hearing the tests of the rockets when I was a kid," Wales said. "It had a very interesting influence on me. Growing up in Huntsville during the height of the space program, and all the exciting things going on with that, kind of gave you an optimistic view of the future, of technology and science."

In the mid-1980s, Jimmy moved to Auburn, where his parents lived for a few years while his mother attended pharmacy school.

Jimmy, too, enrolled at Auburn University, in the finance department.

"My family always placed a high value on education and independent thought," Wales wrote recently by e-mail from his London home. "So I would say that the primary influence was that I probably learned as much studying on my own in the Auburn University library as I did in class!"

He helped pay for his schooling by working at a nursery in Auburn.

"I remember crisp fall days—football weather. I remember working at Young's Plant Farm. I remember riding my bicycle to school."

But Wikipedia was not even a glimmer in his mind at the time.

"I had no clue at all back then," he said. "The original idea of a free encyclopedia for everyone came to me in 1999, two years before the founding of Wikipedia."

After graduating from Auburn in 1989, Wales received his master's in finance from the University of Alabama and became an options trader. In 2006, *Time* magazine wrote of Wales's contribution to shared knowledge:

> He started the way most encyclopedists start, by commissioning articles from experts and subjecting them to peer review. After 18 months, he had a pitiful 12 entries; at that rate, it would take a few millenniums to equal Encyclopaedia Britannica. So Wales created a free-form companion site based on a little-known software program called a wiki (the Hawaiian term means quick) that makes it easy—with the "edit this page" button—to enter and track changes to Web pages. The effect was explosive.

Following the success of Wikipedia, Wales has received honorary degrees from Knox College, Amherst College, Stevenson University and Universidad Empresarial Siglo 21.

He also was listed number twelve in Forbes's "The Web Celebs 25."
Here are a few other cultural and political figures:

- WILLIAM JAMES SAMFORD, circa 1860, attended API for one year, governor of Alabama
- GORDON PERSONS, 1922, governor of Alabama, 1951–55
- JERE BEASLEY, 1959, lieutenant governor, then governor in 1972 when George Wallace was shot
- FOB JAMES, 1957, football All-American, pro football player, governor of Alabama 1979–83, and 1995–99
- GENERAL HOLLAND SMITH, 1901, United States Marine Corps general, "father of modern U.S. amphibious warfare"
- CARL MUNDY JR., 1957, commandant of the United States Marine Corps, 1991–95
- MAJOR GENERAL WILTON B. PERSONS, 1916, special adviser to President Dwight D. Eisenhower
- PAUL RUDOLPH, 1940, prominent architect, chairman of Yale University Department of Architecture
- MILLARD FULLER, 1957, founder of Habitat for Humanity
- DON LOGAN, 1966, former CEO of Time, Inc.
- RICHARD MYERS, master's 1967, chairman of the Joint Chiefs of Staff
- HUGH SHELTON, master's 1973, retired general, chairman of the Joint Chiefs of Staff, 1997–2001
- TIMOTHY D. COOK, 1982, acting CEO, Apple Computer
- SUSAN WHITSON, 1991, press secretary, Office of First Lady Laura Bush
- JOHNNY MICHAEL SPANN, 1992, CIA agent, first American killed in combat after the U.S. invasion of Afghanistan
- ERIC O'NEILL, 1995, FBI specialist who investigated his fellow agent, ROBERT HANSSEN, who was arrested as a spy (the story is the subject of the 2007 film *Breach*)
- RICHARD MARCINKO, master's, U.S. Navy SEAL commander, author of *Rogue Warrior* and several books, film and television consultant on shows such as *24*, recipient of numerous honors, including the Silver Star and four Bronze Stars

About the Author

Kelly Kazek is managing editor of the *News Courier* in Athens, Alabama. In her more than two decades as a journalist, she has won more than 130 national and state press awards. She is the author of *Fairly Odd Mother: Musings of a Slightly Off Southern Mom*, a collection of her syndicated humor columns, *Forgotten Tales of Alabama*, *Forgotten Tales of Tennessee*, *A History of Alabama's Deadliest Tornadoes: Disaster in Dixie* and *Images of America: Athens and Limestone County*. She lives in Madison, Alabama, with her daughter, Shannon, their beagle, Lucy, and their cats, Mad Max, Luvey and Charley.

HOW TO SUCCEED IN A MERGER or, AQUISITION

What should I think? How should I feel?
What should I do?

Danny A. Davis

From the author of the best selling guide to successful M&A,
"M&A INTEGRATION HOW TO DO IT"

Copyright

Edited by Derek R. Ingle

First Printing: 2017. Printed in the UK by Merger & Acquisition Books

ISBN 978-0-9956876-0-8

Special discounts are available on quantity purchases

Contents

Author: Danny A. Davis

Danny is a partner at DD Consulting, a specialist M&A integration consultancy with global connections.

Danny has been a guest speaker at London Business School on Strategy and M&A courses for over a 15 years now and Programme Director at Henley Business School for M&A. He was the youngest ever trustee on the board of the Chartered Management Institute, chaired the marketing and policy committee and currently sits on their "expert's panel". Danny has been published prolifically in business journals including Finance Director Europe (FDE), The British Compute Society (BCS) Developing HR Strategy, Journal of Brand Management, Corporate Financier, The Treasurer, The Chartered Institute of Management Accountants (CIMA) did a profile on him.

His first book "M&A Integration: How to do it, Planning and Delivering M&A Integration for Business Success" provides tools, checklists, lessons learnt from M&A deals and is now on many of the world's top business school courses.

Danny has worked on deals from small to large; a 100 employee company taking over a 25 employee, through to a deal worth $16bn. His contributions have ranged from 2 days training, mobilisation or review to 3 years of running the strategy, planning mobilisation, tracking, governance, delivery and successful integration of a $6bn deal across 30 countries, all functional areas and moving 250 businesses down to 120 and across 26 functions (IT, finance, HR, sales, marketing, etc.)

His blend of strategic theory, practical experience and real life war stories make him unique in this field.

He has also played 28 seasons of 1st Division National League water polo, 10 of those years in the England squad. Throughout this time, he learnt how to motivate individuals and groups of people to perform at a higher level, within intricate dynamic and political environments where people are competing and trying to perform under high pressure conditions.

Introduction

Not only have I run a number of mergers and acquisitions of varying sizes, I have personal experience as an employee of a business that was acquired by a competitor. If your company is acquired, part of a merger or, purchases another company, there is nothing to be scared of. Usually this is an opportunity for you, be positive, seek out how to help and you will probably do very well. Reading this book will enable you to turn the uncertainty into a great opportunity.

My company is being bought, sold or merged, what will happen?

Companies are usually owned by shareholders, often people like you and me. Yes, that sounds odd to say that we own the company, but it's often the case. You save money into a pension, which is put into a large consolidated pot of money and then invested in companies. In many countries the law then requires those companies to make as good a return on your money for you as possible, so that you can live out your old age with some money in your pocket.

That aim of maximising profit is offset by another set of laws which are put in place to look after the interest of people working for the company (works councils, unions, individual protection of employee, group protection of employee), their country and the world generally (environmental laws). These laws, rules or guidelines balance the other set of laws put in place and we end up with a nicely balanced system.

So, senior management would like to improve the company, make it larger and stronger against competition and with the profitability to fulfil its legal obligations. This is often the driving force behind mergers and acquisitions.

What companies do we buy and why?

Technology companies: a new technology or product in our portfolio will mean that we have a fuller range and can thus provide a better service for our customers. In these deals, we will most probably need all the people to support that product

and help it grow. Often we have lots of customers and so can sell the product to our customers (cross selling – see later) and make lots more money.

People companies: a new skill set (process or system) in our company will help development or growth in the longer term. We buy a company containing people who are good at that thing and try to keep or promote them (over a long period of time) around our company to ensure that knowledge becomes part of us.

A supplier: a vertical or upstream merger, if a competitor decided to buy one key supplier, they could then cut off the product, either by no longer selling it, raising the price so it's not worth buying or just making it very difficult to purchase. In this case, we believe the supplier is very important and we will be in serious danger if someone else owns or cripples them. Owning more of the supply chain vertically often leads to more profit overall for the company making the purchase.

A competitor: A horizontal merger, often in an aging industry which is consolidating. Profit and margins are not what they used to be. Shareholders (you and me, through our pensions) are in need of a good return on their money. We buy a competitor and try to squeeze out more money. These are the classic mergers people hear about. The aim is to reduce the duplications and so reduce costs. Often these are very large and complex deals. The key for you is to read all of the other type of deals on this list and see if any apply to you. This list comes from a large deal, where different divisions, functions and parts of the company fell into different deal types. For example, one large deal I ran contained duplication in one area, but in other areas there would be growth, with good people, technology, products and customers. We must approach each part of the company in a different manner, to maximise profit. So don't be too concerned by this type of merger, it does depend on where you sit in the company. This is also known as the merger of equals or the classic overlap merger.

A conglomerate: there are a number of companies that are made up of a vast number of different divisions. These are often stand-alone divisions, with little to no overlap. Providing good management to these companies enables them to be run better, more money enables them to grow faster, more connections or knowledge, so we buy them. There is often overlap in the customer set, so cross selling takes place (i.e. one of our companies sells to the other's customers). Sometimes this is as simple as changing the brand. There can be overlap in other parts of these companies but the general aim is to invest money in growth avenues or, buy more companies. There is little money to be made in reducing the small amount of duplication (remember that cutting duplication needs investment to kick it off). We see strategies from leave the company alone… through to full integration….

Reverse takeover: the company is bought by a larger company, but in our country or division we are much larger than the company that bought us. In this instance, we have better people, product or economies of scale, than the purchasing company and they know that. They might change one or two senior managers to ensure they have control. However they will let us run the merger and be in charge of what happens. This often confuses people, since they see the horizontal (competitor) type merger going on around them in other divisions or countries and so incorrectly assume those things will happen "in our bit".

New country: we are not in a certain country and would like to have a foot print (or business) there, so purchase for geographic expansion, in an attempt to try and get larger. There will be overlap and duplication between the companies, but it usually cannot be removed. We don't know the local market and don't want to mess up a good company we have just paid good money for. Often there are local rules and regulations that mean we need local people to run the company, speak with customers, suppliers and understand how business is done locally. Often there is virtually no cutting or changes. Everything is about how the new parent company can help local growth.

It doesn't matter if it's an acquisition, merger or has been called something else; someone must be in-charge for it to work well. Someone has bought someone else and that person or company values you – they paid a lot of money for you. Help them generate that value and they will "like" you!!

Growth mergers

Most mergers are about growing the company in some way. Often in large mergers, there is a portion of growth and portion of consolidation. We intend to invest in the areas that will lead to growth now and in the future. So start to think about where those areas might be within the newly combined companies. These are the areas that will do well. Usually it's clear to the purchasing company where to invest money, time and resources, but it can take time to figure out exactly how to do it or to tell everyone about it. So it's very useful for people to think about this and be helpful. Clearly if you understand and can explain why some part of your company will do well, then this will greatly help your chances of getting that investment. This is actually no different to normal day to day business; this is how companies are run.

The key is that we are looking for short and long term growth of our company and if you can help with that, you will prove invaluable. People that start to play silly political games and hinder that, will not do well and sooner or later do quite poorly because of this.

Growth and synergies

I have described numerous types of mergers. Often a larger one will contain a number of parts to it, in different functions, business units, divisions and countries. Now we can start to talk about the growth of our business.

People often imagine this picture when they think of a merger (1+1=3). However it is a little more complex than that, as you have already seen. So the real

questions are, we have a pot of money to invest as a company, which areas should we cut back on and where should we invest to enable the growth.

To actually put pieces of the company together will take management time and cost money, so we will only do this where it seems useful. There is no point in wasting money, changing people, processes or, systems if there is no future benefit. Why bother?

Cross Sell

We might think of these as places where we will increase our revenue, sales, margin or profit. Often these have some sort of interface with customers. Clearly the first thing we must do is ensure all our customers are happy and that they all stay with us. We have just paid a large sum of money for them; they are the people that give us our income as a company (sometimes I hear people say, "The customers pay our wages"). Competitors will come and try to steal our customers and we must be ready.

That said, both companies XXX and YYY have a set of customers. We can now sell our products to the other company's customers, this is called cross selling (remember that virtually nothing else needs to be consolidated or changed in either company for this to happen). Company XXX can now sell product A and product B to its customer CVB and company YYY can also sell both to its customer HJK. In this manner, at very little cost for our sales process (since it's always very difficult to find new customers for our products and services) we have increased our sales. Revenue is up and profit will increase. Often this is a very large part of the reason for mergers; sometimes there is nothing else to the

merger apart from this. In Order for the cross sell to happen, we will probably want to change the brand names so customers can see what is going on. For this

to be achieved, we must create new marketing literature to show all our products, train our sales and marketing people as well as all customer facing people on this new and increased product range.

The key thing for you to remember is that a growing company requires more people to do all the work and not less. However they do need the right sort of people. They need people who are all pulling in the same direction, of growing the company. If you're helping to grow the company, chances are you will do well, in both the short and long term.

Up Sell

There is also the possibility of increasing the margin (profit) we make on some products. If there is some duplication or overlap of the product ranges when we look at the lists from both companies put together, we can then choose the duplicate product which is not only "best", but also provides the most profit. Sometimes the best product costs more, but often it doesn't.

Through consolidating the product range in some way or just choosing one of the two, we can then reduce our cost of production overall and make more profit from the same volume of sales. This portfolio rationalisation is often a part of mergers, can not only increase the average margin of the products sold, but also increase volume. How could volume increase? I hear you ask? Well, if the cost to produce decreases, so then our margin increases on that product. Sometimes we decide to reduce the price to the customer a little because we think we will be able to sell more. Volume may increase because we are a larger company and customers view this as valuable and will purchase more of their goods from us.

Cost synergies

Here the tough part starts. There is sometimes duplication between the two companies. There seems little point in having duplication, if it is removed, the cost base will decrease and the profit improves. Let's start with the assumption that where there is overlap, we will see if it can be cut.

For example HR will have some overlap and so potentially we don't need so many HR people. At first glance this is correct. Let us then add the question "what does HR do?" It supports the people in the business. If there are the same number of people in the business, it's very possible that the same number of HR people will be needed to support it. Clearly, if all the people can be amalgamated then the same might be possible with HR. However, this is usually heavily dependent on geographic location. If we have an office a long way away from another, we will most likely need to keep the HR people in both. If there are offices in different countries, then there are different HR laws to adhere to and local HR presence with local knowledge will be needed. This all said we will clearly be looking to see if overlap and duplication can be cut in accordance with how HR can be made more efficient.

Therefore, cost cutting does occur in this area. When it comes to IT, this is another support function similar to HR where, there is overlap and duplication. Again we would like to make our company more efficient and if two IT systems can be cut down to one - saving money - then this will be looked at. This is generally not an issue at all, since to consolidate 2 to 1 in IT often takes anywhere between 9 and 18 months to

complete, sometimes more with large companies. The IT people have to help to actually prepare the systems, clean the data and migrate it across. Usually the changes must be announced well in advance of the work starting, and so IT people will have 9-18 months to be-retrained on the new system or find another job elsewhere in the company or with another firm. Though this can seem like a shock, many people who have a lot of time to prepare end up getting paid not just their monthly salary, but sometimes a bonus for staying until the date they are needed and then they find a better paid job elsewhere. So don't be too concerned about people who will leave the company and have this much prior notice.

Finance nearly always has some overlap and there should be a few less people. If you're sitting in a very small finance department, it's tough to consolidate your jobs elsewhere, since you're so specific to the customer facing part of the business. However, there will be a push to try to see where work that is duplicated can be done elsewhere. Cuts do often happen in Finance.

In each of these three cases, I have in my mind this picture of consolidation of repeatable process. On the top of the diagram I have 4 units with separate finance departments and on the bottom I have kept people in the local unit at a senior level or where there is little repeatability in process or task. However, the lower level items, like invoicing, can be brought together and cost cutting

delivered. Moving to a common IT system is often not possible for years. If units are located in different countries, consolidation will be difficult and again may not be cost effective changes. Exiting people (with redundancy) and then hiring and training new people in another location – often just is too expensive to do, if we look at risks of the consolidation.

Becoming part of a larger company

It's going to be tough becoming part of a large company. As a general principle there are differences between two companies sometimes it's as simple as the power and structure. A smaller company is run differently to a larger one. In the larger one, it is impossible to know everyone or what they are doing. Therefore, more processes and controls are put in place to reduce the risk of a "rogue" person heading off in the wrong direction. This often seems like the larger company forcing its way of doing things on the smaller company.

Another way to look at it is that until you learn how the new company works, how decisions are made, where the power sits and who controls the budgets (or money), then things may be tough. The simple answer is to learn how things work and learn how to fit in. If you know how to ask for money and why people give it, then you can go get some.

Over time you will find there are many more opportunities in a large company for your future prospects. These include: better chance of promotion, more interesting and varied work, many more learning opportunities. Life can seem much better, for most. Some, however, decide it's not for them and they leave. It is for you to decide what the future holds for you, what your best options are and to act accordingly. A large company brand on your CV for a few years often looks good.

What will happen to our current leadership?

When we look at the top people in the company, it is obvious that there is overlap. Two CEO's and FD's, with duplications across the two boards, or, management teams. Clearly this is not optimal from a cost view point, but also the political fighting will not help either company. With two CEO's, who is in charge, who will be followed and who should be listened to? There is often decisive action required to put a new team in place from the very start.

Will this affect me?

Not necessarily. The concept that the top team needs to change, will mean their direct reports need to be moved around. This doesn't necessarily imply any more changes or cuts below that level. So don't read too much into this.

What will happen to my job?

I can't say for sure. It does depend on why your company was purchased, where the growth areas are and where the overlap is. Then how difficult it will be to remove or change that overlap.

Don't be too concerned at the moment. Try to find out why the company has been bought and what the stated plans are. People rarely want to lie, so if you're told everything will be ok, it probably will be. Remember, this is all being run by people. People always try to be good to each other (well that is my experience of management).

If you're in an area that might do well or grow, or, is a stated reason for purchase, then possibly or rather probably you will do very well out of the merger. Are you in an area where there is obvious overlap? Well then you might be slightly more concerned. Often mergers do look to make savings of 5-20% across both of the companies (e.g. 3% from company A and 2% from company B, making a total saving of 5%), though not necessarily in reduction of people. So the questions to ask are around where is it easy to make these changes and deliver these savings. For people to be removed, then the work

Management Team

must be removed to. Is it possible for the company to stop doing what you do, or if they put everyone in one room doing it would it be much (and I mean much, much) more efficient?

If the answer to these questions is yes, then it's possible these savings are being looked at. I would be very positive towards any changes and don't try to fight against them. Try to find out as much as you can about them. Be patient, be

positive and don't gossip too much. Try to over deliver. It makes you look good if there is a choice between people. In the background, I would also start to get my CV ready and also potentially start looking around at the job market.

Don't jump yet. Sometimes a company will decide they want you, so there is no need to jump into the unknown. Occasionally certain people are needed for a specific period of time, e.g. 7 months. If I want you to stay 7 months, I will need to come and ask you to stay until a certain date this will probably give you some incentive to stay till that date (often a bonus) and then you have an end date with plenty of time to look for a job.

It is usually the uncertainty of the unknown that causes people distress. However now that you know what will happen, there is less uncertainty for you.

What will happen to my department or project?
Generally departments just get moved around, and there is not a great deal of change, unless there is a lot of duplication, as stated above. As for projects, well, this depends.

If a project is taking the company in the wrong direction, this is wasted money and so the project should be stopped as soon as possible. E.g. you're an IT person helping to improve your SUN ERP system and you're bought by a company with SAP. If the decision is to move from SUN to SAP, then any money invested in improving SUN will be wasted money. So these projects should be put on hold or stopped. There is generally little to worry about. When the "change SUN" project stops, a new project "move from SUN to SAP" starts and so there will be a need for people who understand SUN. There will also be many other integration projects that start up.

So if you're on a project that needs to change, slow or stop, don't worry. There will be other projects and you will probably be moved onto one of those.

However, that doesn't solve the problem entirely. Since then there is the question of what will happen to me once that project ends. There will be jobs with many people moving into business roles and having their knowledge used. Some will eventually not be needed. There should be plenty of time before this happens and so you will see it coming and be able to look for a job elsewhere. There will be a few (very few) where this is not the case and their projects are cut

and they don't have the skills that fit a new project. The reason these will be very few is that there is extra work during the integration. All the work of two companies must be done and the work of putting them together too (integration projects). If you are removed from the company, that costs money. Then to hire someone in again costs more money and so, we try our hardest not to do this. Job change and re-training is often the ideal.

What will happen to my pay?

Essentially nothing will happen to your pay and benefits. Now, that's not quite true, but we cannot come along and reduce your pay, you would become annoyed and potentially leave the company. Since we don't want everyone to leave, we will not reduce your pay.

The company that just bought us has different terms and conditions (T&C): pay, stock (options), other benefits and vacation time. Surely they will change ours. Possibly, they might think about doing that. It might be more efficient to have everyone on the same T&C's, but to change everyone over, we will usually need to ensure that very few people are worse off "overall" i.e. if we reduce the pension you have, this money will need to be made in some way elsewhere. This change often costs the company money, rather than saving money and so eventually after a lot of thinking and analysis, most companies decide not to do this. If we do, people are in roughly the same financial position as they were to start with. A few people will be slightly better off, nearly none will be worse off, though some might perceive that they are worse off! This is not a big issue or of any real importance, I wouldn't bother thinking about it too much.

Who will my boss be?

Doesn't really matter who your old boss was or who your new boss is. If you're working well and heading in the right direction (already discussed, growth) then you're going to do well.

Will our office move?

Will I have to move? This is a question often asked. Though I have been able to give you quite a good understanding of how other decisions are made, on this subject, your guess is as good as mine. It will depend on your business locations and consolidation plans. Remember that there is usually a long term rental contract in place for offices and other locations. So the analysis can be done on

the property portfolio and decisions made – to stay or change around – but there is usually a long wait until the contracts are up and changes can happen. Often this becomes common knowledge in mergers, so I am sure you will hear about this on the grape vine.

How will I feel?

Let me tell you about the change curve, here is a picture of it, but you can read much more about it on the internet. It originates from a grief curve, quite useful for me when my grandfather died. Knowing the stages of change that you might go through during that period of stress.

At the start we are informed about some sort of change that may happen. This sometimes is seen as either positive or negative and we start along the curve. The next thing is to deny that this change is happening or that it won't happen to me. After that we might get angry, "Why wasn't I asked about this?" "Who cares about what I think?" "This is wrong?" or "They shouldn't do that?" With follow up thoughts around new options, other things that "they" could do. We are exploring other ideas or ways of doing it. We can now start to see the light at the end of the tunnel and moral starts to improve we become happier, begin to understand and accept the new ways of doing things. We can see the direction the company is taking and may eventually become an advocate of it, encouraging others to accept it and helping them through. The idea, hopefully, is that at the end we are happier than at the start.

The things to remember about this are not everyone goes through the emotional rollercoaster in the same way:

- Some people will skip stages
- Some people will not show visual signs that they are going through it, but others will
- Some will get stuck in the bottom and need your help to get up the other side
- Some will go through it faster than others, may be weeks, whilst others may take months or longer

You will also be affected by the communications that go around the change. These are aimed at telling you what's going on and help you through the changes. Often people are unhappy with the amount and quality of what they are being told. That's perfectly normal though, I went through one myself and was made redundant, so I understand how it can make you feel uncomfortable or a little unhappy. In fact, that is exactly what the change curve is suggesting will happen.

The key, is how long it takes you to get through this curve and out the other side. This is mainly down to the length of the change. Generally once people know the lie of the land, for them, suddenly they get much happier. Remember the change will take more or less time dependant on which department you are in. Some will go fast and others more slowly. However, it is clear to me that people who understand the changes that are going on and understand how they will think and feel (e.g. know the change curve and that they will go through it) will be much more positive and happy about their situation. As such they will get through the emotional ups and downs in a more efficient manner.

How can I do well out of this merger?
We have already discussed this in a roundabout manner, but here's a quick recap:

1. Be positive and show it
2. Don't be negative in light of the circumstances and don't be seen as negative towards the new way of doing things. This will only look bad to people above you and demoralize those beneath
3. You can be constructive and helpful, have the right attitude

4. Mentally commit to becoming a part of the new team
5. Don't think about how we used to do things talking about the past makes you look like your resisting the change
6. Be proactive. Show what you have done lately, how you have added value and will continue to do so. What results have you achieved? What skills will the new organisation value? Sell yourself! Think about what the new company will want. Possibly growth, possibly other things too. How can you help?

Questions people often ask

How many people will go?
It is impossible to tell, without knowing more about your merger. Go back to the start of the book and look at the different types of mergers that happen. Some aim to keep everyone, some to remove the fat and some to remove the duplication.

Where will they go from?
We try to remove people from the area where 2 people are doing a job that could easily be done by one person (given a slight trimming of the workload). If you will aid the growth of the company, you're probably safe.

Who will do well?
People that can show they will help the company achieve its goals and achieve them faster than expected. These people will generally do well in work, not just mergers. So this is little to do with mergers and deals, instead it's more to do with people that do well in business. If you are doing well normally, then you will probably do well during the merger.

How can I position myself to do well?
We look for the people that are fighting against the company, the direction it's going in stopping it working and these are the people we want to remove first and foremost. The bus is now going in this direction, come with us or get off the bus.

How does a selection process work?

If there are to be redundancies, then a selection process will be set up. The laws are different in each country, so sometimes this is slower than others. There are a number of ways to manage this, but what usually happens is we choose the top management team and then let them select the people below them. This process carries on down the organisation.

This has the benefit of each manager having a team that they have selected and bought into the new organisation. However, this also means that rather than someone (HR and the CEO) sitting down and drawing an organisational structure with all the people in the boxes, this fairer and better selection process will take weeks or months to get through. This slow process, means you have to go through that period of uncertainty and so the change curve.

Planning the integration

The integration of the two (or more) businesses, is usually planned as early as possible and in as much detail as possible. If we think about a normal IT project, we create a list of things to do, how long will they take and who will do them. To start with, we might need to go and find out lots of information – i.e. what data do we need in the IT system. We can't build it until we know that.

Same in a merger, we will create our plan for change but many things at the start are still unknown. We have a good idea of where we need to head towards, but need to find out a lot more information about the company we have just bought before we can make all the detailed decisions.

Communications

How are the communications planned? Firstly we need a project plan for the integration. This will be completed for each function and part of the business. Then once we know what we are going to do and when, we can lay down a plan to tell each audience of people what is going on. Sounds simple, but it's not. At the start we know the high level things that will happen, but generally need a little time to gather data and would quite like to ask the people in the purchased company what we should do. Often we have plans but would like to double

check them with senior people. We also like to make the more detailed plans together with junior people in the acquired company.

Now, we have a general idea of where we are heading so we can communicate that, but if we don't yet know specifics we can't communicate specifics. It's always a good idea to check things, plans, ways forward, before communicating them (since then they are set in stone). So this is why sometimes communications look vague or seem like there is not enough.

Mainly they are very good. It's just you're going through the change curve, you want to know everything that affects you, your job and your future. Often we just don't know everything or can't tell you because the planning has not been done in enough detail yet. Communications often annoy people because they are limited, though they have to be because of the way things work.

Politics

There always seems to be a lot of politics in mergers. Things are about to change, or are perceived to be in a state of flux. This means that there is room for people to start playing games. Some people do well from this in the short term, but my general opinion is this sort of thing annoys managers above and cannot be good for you or the company in any sort of way long term. Certainly I see this as slowing the business down, people playing politics are getting in the way of growth and more profit. I aim to remove people who are overly political.

That said, not all managers will agree with me in this view. Also a certain amount of EQ, or understanding of the situation and how to interact with people, is always going to be useful. As a general principle, senior people I know don't like "bull shit", they can see through it and this will not help your cause long term.

New power and budgets

There will potentially be a movement of where the power and budgets are in the new organisations. This will be dependent on where we see the growth of the future coming from and who we think will deliver it.

So there is a chance that if you look "good" I mean that in the sense of good at your job - useful to the acquirer and doing all the positive things I have already talked about, then possibilities are, that your well on your way to gaining more power, a larger budget (in time) and eventually promotion.

Rapid promotion for good people

A large company buying a small company will want to make good use of the skills and people just purchased. One often used strategy is to send a very positive message down to the small company. Look for some good people, with useful skills and promote them up and out across the larger organisation, or just upward in their current area. This is usually planned. Clearly it can only be done with a few people and at the very start we don't know who those good people are, so you may slowly start to see this happening over months or even years. There are usually great prospects for good people, so think of this merger as an extremely good opportunity for your future career.

Other books and articles by Danny A.Davis

- M&A integration: How to do it – Planning and control published by Wiley press (Book)

- Point of View: "Planning for success after a merger" published by Henley Business School
- Point of view: "Many Paths - alternative integration strategies and the drivers that make them work" published by Henley Business School
- "Integrated branding with mergers and acquisitions" published in Journal of Brand Management
- "Cash in transit: What must treasurers consider in the event of a company M&A?" Published by The Treasurer
- "The Role of HR in successful M&A integration" published by Developing HR Strategy magazine
- "Take the Long View" published by CIMA Excellence for Leadership magazine
- "The Reasons for Change" published by Twenty:10 - Enhance your IT strategy (British Computer Society)
- "M&A Roundup - Movers and shakers" published by M&A deals
- "How to Restructure the Finance Function" published by Finance Director Europe Magazine
- "Shaping the Future Business" published by Finance Director Europe Magazine
- "Sales force integration, who is minding the customer?"
- "IT M&A Integration" published by the British Computer Society
- "Non-Profit Mergers" published by The National Charity for Trustee magazine

Training provided by Danny A.Davis

M&A Training Courses: Danny A. Davis runs regular training sessions on various aspects of M&A, including 'Successful M&A Integration Programmes'. These are open to clients who would like to learn more about how to plan, mobilise, evaluate, track and deliver integration programmes. These sessions have also proven very useful to those participating in internal integrations of functions, businesses or departments. Often labelled as efficiency, change programmes or transformations. With courses provided to corporate, private equity and non-profit, charity, government. He also delivers **bespoke in-house M&A Training**

M&A Coaching: Danny A. Davis runs a consultancy which helps people through their deals, with personal or group coaching. We have numerous coaches and consultants across 20 countries.

Please contact Danny for more information.

Feedback on this book

I would love to know if this book was useful, additional sections you think should add, questions you have?

Send me an email www.ddavisconsulting.com

M&A Integration: How to do it, Planning and Delivering

Danny A.Davis' first book "M&A Integration: How to do it, Planning and Delivering M&A Integration for Business Success", was published by Wiley. The book provides tools, checklists and lessons learnt from M&A deals and is now on MBA, executive MBA or Global MBA course reading lists at CASS Business School, Owen, South Carolina, with the first chapter being handed out to students at London Business School, Vlerick, Cornell, Insead and many more of the world's top business schools. The book is also praised by practitioners who plan and run deals

all over the world. Some use it to dip into in times of need, the bible on their shelf. Others have used it to take them through a deal as integration director or part of the integration team.

"This book gives a good introduction and comprehensive overview to the topic 'M&A/ PMI' every company has to find its own approach and requirements but Danny Davis provides a pragmatic and practice orientated guide." Bernhard Falk, Head of Practice Group PMI Excellence, BASF

"Every M&A expert recognizes that implementing a well thought out post-merger integration plan is the key to value creation. Davis draws on his extensive experience to provide a useful roadmap of issues to consider. This book will help managers face the complexities of post-merger integration with confidence and insight." Phanish Puranam, Professor of Strategy and Entrepreneurship, London Business School

"I think this is one of the most comprehensive and straightforward guides to M&A's that I have read. It demystifies a lot of the consultant speak and is pitched at the right level for managers and leaders who are most likely to face the M&A challenge." Richard Beaven, Customer Service Director, Lloyds Banking Group – Insurance division, Lloyds Banking Group